IDAHO RUFFED GROUSE HUNTING

The Heartbeat of the Woods

ANDREW MARSHALL WAYMENT

Published by The History Press
Charleston, SC
www.historypress.com

Copyright © 2018 by Andrew Marshall Wayment
All rights reserved

Front cover: *Chance for a Double-Ruffed Grouse*, by Eldridge Hardie.
Back cover: *Doubled Down*, by Ross B. Young.
Opposite: The author and his beloved Brittanys, Misty and Sunny Girl.
All other images by the author unless otherwise noted.

First published 2018

Manufactured in the United States

ISBN 9781467138444

Library of Congress Control Number: 2018940076

Notice: The information in this book is true and complete to the best of our knowledge. It is offered without guarantee on the part of the author or The History Press. The author and The History Press disclaim all liability in connection with the use of this book.

All rights reserved. No part of this book may be reproduced or transmitted in any form whatsoever without prior written permission from the publisher except in the case of brief quotations embodied in critical articles and reviews.

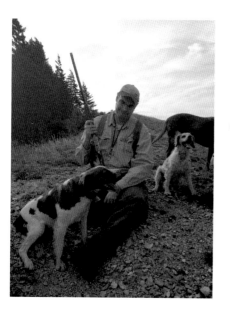

This book is dedicated to my father, Keith M. Wayment, MD, who instilled in me my love of the outdoors; to my wife, Kristin, who has supported me in my fly-fishing and bird-hunting addictions and who has proofread everything I ever wrote on those subjects; to my brother Shawn K. Wayment, DVM, who taught me everything I know about bird dogs and the upland shooting life; and last, but certainly not least, to my Brittanys, Sunny Girl and Misty, who passed over the Rainbow Bridge shortly before this book was published. They enriched my life more than I can say. The grouse woods will never be the same without them.

CONTENTS

Foreword, by Matt Soberg	7
Acknowledgements	9
Introduction	11
1. The Progression of a Bird Hunter	15
2. A Better Way	18
3. Grouse-Hunting Lawyers	21
4. Grouse and Apples	27
5. Still Hunting	30
6. Western Grouse Dogs	34
7. Cover or Covert?	40
8. Grouse Springs	43
9. Think Twice about Hunting on Your Wife's Birthday	48
10. Mixed Bag	51
11. The End of the Road	57
12. Ruffin' It with Misty	60
13. Desperate Days of Grouse Hunting	68
14. The Cowboy and the Hippie Go Hunting	77
15. The Outhouse Covert	82
16. Conversation with George	86
17. Twenty Things Every Brush Worn Should Know about Ol' Ruff	94
18. Glory Days	98

Contents

19. Who Is the Best Writer on Grouse Hunting?	102
20. The Blazing Saddle	106
21. The Garage Band	111
22. Of Hearth and Home	114
23. The Song of Harvest Home	119
24. A Matter of Life and Death	124
25. No Sense to Come In Out of the Rain	129
26. We Only Get So Many October Days	133
27. Eye Opener in the Beaver Meadows	138
28. Easy Pickins' and Butt Kickins'	142
29. Last-Hour Grouse	146
30. The Heartbeat of the Woods	150
31. A Grouse Hunter's Dream	152
32. The Perfect Feeling	157
33. Grouse Therapeutic Session	162
34. Bona Fide Grouse Dogs: William Harnden Foster Was Wrong about Brittanys	166
35. Rip Van Winkle Was a Grouse Hunter: A New Take on a Classic Tale	171
36. Discovering Tinkhamtown	178
Glossary	185
Bibliography	189
About the Author	192

FOREWORD

It was October in a past life. As I packed my briefcase after a long-fought trial and trudged soul-squeezed and mind-drained from the courthouse, I had one saving grace: ruffed grouse, the Heartbeat of the Woods, would be my lifeline to find the tranquility of the bird, the woods and the experience. The stress of day-to-day trials and tribulations coupled with life's responsibilities made ruffed grouse hunting so essential to pump lifeblood into me each fall. The passion and traditions surrounding ruffed grouse are unrivaled. I need ruffed grouse and ruffed grouse hunting.

As a fellow lawyer, Andrew M. Wayment knows all too well the trials and tribulations of which I write, and this book is a testament to his ability to translate a heightened sense of connection with ruffed grouse, specifically between the hunter and the hunted. As grouse hunters know, these traditions carry with them cherished experiences with friends, family and bird dogs, relationships with inherent emotions that are difficult to communicate and memories we never forget. As a contributor to the *Ruffed Grouse Society Magazine*, Wayment has proven the ability to translate these personal memories into relatable emotions for hunters, and he has certainly shaped those feelings in a meaningful way here too.

What is it about ruffed grouse that is so captivating, mesmerizing and almost debilitating? How often do you stand in awe of a bird post-flush with admiration for their ability to evade both hunter and dog? Embrace the challenge, I say, and enjoy every moment because life is way too short. Just as I do on a mid-October afternoon afield, I found myself leaving my muddled

Foreword

mind behind and getting lost in the northwoods with bird dog in tow as I thoroughly enjoyed reading each story of this book.

I so admire our famed writers of uplands past and feel it necessary to honor those who have come before us. If only we could walk in their shoes to experience the sights, sounds and smells of a day afield as they experienced it and so eloquently storied in their books. In an essential way, *Idaho Ruffed Grouse Hunting* honors the history of upland literature with quotes from the likes of Aldo Leopold, Corey Ford, Burton Spiller, William Harnden Foster and many, many more. But who will carry the torch forward as upland writers to the next generation of grouse hunters? I believe *Idaho Ruffed Grouse Hunting* goes a long way to traveling down that road.

Our secret ruffed-grouse coverts, those we name and those upon which stories are told from generation to generation, are born from young forests created by disturbance or scientific forest management. Although stories are generational, those coverts are not…without periodic management, and this sentiment is not lost in *Idaho Ruffed Grouse Hunting*. If we want to continue to preserve these special sporting traditions, we must create healthy forests for abundant forest wildlife now through proper forest management from the federal to local levels. I want to tell these same stories from the same coverts to my children and grandchildren, and to do so, a focus on forest conservation is key.

Upland hunting books are cherished, while ruffed grouse hunting books are one-of-a-kind. *Idaho Ruffed Grouse Hunting* captures everything we love about ruffed grouse, forests, family, friends, faith, dogs, conservation and much more. Enjoy.

<div style="text-align: right;">

Matt Soberg
Editor and Director of Communications
Ruffed Grouse Society

</div>

ACKNOWLEDGEMENTS

Some of the chapters of this book first appeared in some form in various magazines: "Discovering Tinkhamtown" in *The Upland Almanac*; "Grouse and Apples," "The Song of Harvest Home," "The Heartbeat of the Woods" and "The Perfect Feeling" in the *Ruffed Grouse Society Magazine*; and "A Grouse Hunter's Dream" in *Shotgun Life*. I first thank the magazine editors, Tom Carney, Irwin Greenstein and Mathew Soberg, who accepted and improved my work and for granting permission to use these pieces in this book.

I appreciate Matt Soberg, the editor of the *Ruffed Grouse Society Magazine*, for agreeing to review the manuscript and for writing the foreword. Undoubtedly, Matt, a recovering ex-attorney, has helped to make the *Ruffed Grouse Society Magazine* one of the best upland game hunting magazines out there. Keep up the good work!

I also need to thank Dartmouth College, Rauner Special Collections Library Department, which is the heir to Corey Ford's literary work, for permission to use quotes from Ford's original version of *The Road to Tinkhamtown* in "Discovering Tinkhamtown."

Lastly, I must thank the artists who so graciously gave permission to use their beautiful art in this book: Eldridge Hardie for the beautiful cover painting, *Chance for a Double-Ruffed Grouse*; and Bob White, Ross B. Young, Peter Corbin, Jason S. Dowd and M.R. Thompson for the other excellent artwork that appears in the book. Without a doubt, their great work beautifies this book and makes it better. It is an honor and a dream come true to collaborate with these talented artists.

INTRODUCTION

You've heard of the wonders our land does possess,
Its beautiful valleys and hills.
The majestic forests where nature abounds,
We love every nook and rill.
—"Here We Have Idaho," Idaho state song

The ruffed grouse is considered by many hunters to be the king of the uplands because of the long, rich history of grouse hunting in the eastern United States. I have no way of gauging this, but I believe that more books have been written on ruffed grouse hunting than any other game bird. In my humble opinion, some of the best hunting books have been written on the subject.

When you think of ruffed grouse hunting, you probably do not think of Idaho. Hopefully this book will change that. In 2013, a wonderful book was published on ruffed grouse hunting titled *A Passion for Grouse: The Lore and Legend of America's Premier Game Bird*. This book contained chapters on grouse hunting in New England, the southern Appalachian Mountains and the Great Lakes states, but nothing was included about hunting grouse in Idaho or the Rocky Mountains. With 549 pages, I understand why, but as a western grouse hunter, I still felt a little left out.

Truth is, Idaho is one of the best-kept secrets in upland bird hunting. Few other states support such diversity and abundance of game. Idaho has nine upland bird species that are regularly hunted with dogs. Of those nine, five

Introduction

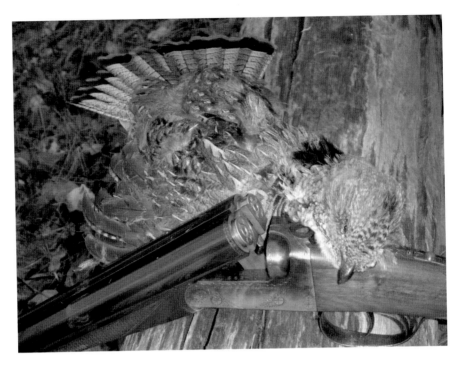

The bounties of October.

are native to Idaho: blue grouse, sharptailed grouse, Franklin grouse, sage grouse and the ruffed grouse. Each grouse is a special game bird in its own right, but ruffed grouse are my favorite.

On top of that, over 60 percent of the landmass in Idaho is public land, most of which is open to hunting. Most eastern grouse hunters who are rapidly losing coverts to development, loss of access, old growth or myriad other reasons cannot even begin to fathom the vast amounts of acreage and grouse cover open to hunters in Idaho who are willing to get out and explore a little.

Some writers in the past have disparaged the ruffed grouse of the Rocky Mountains by claiming that they are not the same game bird as back east, even saying that they are the quintessential "foolhens." To this, I say, "Hog wash!" Admittedly, in remote areas where they have little contact with man or bird dogs, ruffed grouse can be a bit naïve and will flush into the trees for protection. However, as Idahoan Ted Trueblood wrote in "The Education of Ruff," ruffies can be educated to provide great sport. After almost twenty years of hunting ruffies in Idaho, I can attest that this is true. I've been burned too many times by ruffed grouse to disrespect their skill on the wing.

Introduction

Not only does this book chronicle my near twenty years of grouse hunting in Idaho, but it also celebrates the grand sporting tradition of ruffed grouse hunting throughout the United States. My hope is that any lover of the ruffed grouse, bird dogs and our wonderful tradition will relate and enjoy this book. With that said, I give you *Idaho Ruffed Grouse Hunting: The Heartbeat of the Woods*.

Chapter 1
THE PROGRESSION OF A BIRD HUNTER

There are two kinds of hunting: ordinary hunting, and ruffed-grouse hunting.
—Aldo Leopold, A Sand County Almanac

When I first started bird hunting over fifteen years ago, I preferred—over any other game birds—those gaudy Chinese birds of the grasslands so colorful and beautiful that they would capture any young hunter's eye and heart. But like the mythical sirens of old, I soon learned that a ring-necked pheasant's beauty is only skin deep, and they love to prey upon the tender psyche of young hunters and their pointing dogs. Fortunately, I quickly realized that there are less frustrating birds to hunt.

I've always had a tender spot in my heart for valley quail. But when bird numbers are high, they can frazzle your nerves like no other. If you're up to it, there is no finer shooting. I love it but cannot take that intensity every day. In 2011, I shot a limit of quail one day in western Idaho, and the next day, I could not connect with a single bird. I suppose it's because I did not have the hyper-focus necessary to hunt those crazy, top-knotted birds two days in a row.

For many years, I raved about blue grouse and sharptail hunting, with the blue grouse taking the lead by a small margin. Blue grouse hunting in September will always be one of my favorites. They are an underappreciated, grand game bird. Hunting sharptails in eastern Idaho during October, the very height of creation, is also good for the soul. E. Donnall Thomas Jr. didn't call them "Soul Chickens" for nothing.

Idaho Ruffed Grouse Hunting

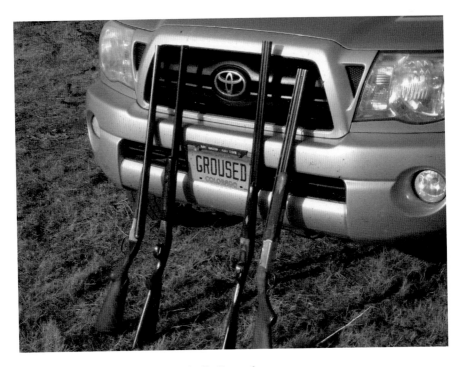

Shawn Wayment's license plate says it all: Groused.

I must admit, however, that my preferences have changed over the years. I have always appreciated the ruffed grouse, but they were never at the top of my list, or even second for that matter. At one time, I considered them one of my nemesis birds. But now, suddenly, I prefer to hunt ruffies over all else, even blue grouse.

In "The Education of Ruff," Ted Trueblood described his own similar experience in this regard:

> *Occasionally a single, or even a covey of blue grouse, wanders down into the ruffed grouse covers in the river bottom or along little streams. When this occurs, we welcome the opportunity to collect some of the larger birds. The time was when we gave them preference, but now we seldom climb the long slopes to find them. We tell ourselves Ruff gives us more sporty shooting in his heavy covers—which is surely true—but maybe we are getting older, too!*

So now the confession: I unabashedly admit that I *love* ruffed grouse and ruffed grouse hunting more than any other game bird. What's not to love?

The Heartbeat of the Woods

I love their habitat, the secret coverts in which they reside. I love their skill on the wing and agree that they are "the trickiest thing in feathers." I love snap-shooting in thick cover. I love their tasty flesh cooked on a fiery grill.

I love the rich history and literature of ruffed grouse hunting. This bird has inspired some of the greatest outdoor writers of all times: Burton Spiller, George King, Corey Ford, Grampa Grouse (Gorham L. Cross), William Harnden Foster, Bill Tapply, George Bird Evans, Ted Trueblood, Mark Jeffrey Volk, Ted Nelson Lundrigan, Steve Mulak, Harold P. Sheldon and so many others.

The pursuit of this bird has produced some of the most beautiful outdoor artwork ever. Think of Ogden Pleissner, Eldridge Hardie, Lynn Bogue Hunt, Aiden Lassell Ripley, Ross Young, Bob White, Peter Corbin, William Harnden Foster and many, many more.

While I love and appreciate all upland game birds and my falls are much richer because of them, there is only one "King of the Uplands": Ol' Ruff! Such is the progression of this bird hunter.

Chapter 2
A BETTER WAY

A bird that is to be the target for a shotgun deserves the chance to fly.
—Ted Trueblood, "The Education of Ruff"

I recently reread Burton L. Spiller's *Grouse Feathers* and thoroughly enjoyed it. Spiller's book got me thinking about my beginnings as a grouse hunter. It seems every grouse hunter remembers that first bird taken on the wing. In fact, many writers have written about that seminal moment in their lives. I figured it was time that I recorded mine and some of the lessons I learned at the time.

I didn't start bird hunting in earnest until my first year of law school up in Moscow, Idaho, in 1998. That year was pivotal in my life. I had graduated from undergrad in the spring and had moved to northern Idaho to attend law school. At this time, my love of the outdoors began to blaze, and I was in a beautiful, game-filled area. On the other hand, I really struggled with the negative law school environment and saw it as a struggle of the survival of the fittest, which didn't sit well with me.

In my book *Heaven on Earth: Stories of Fly Fishing, Fun and Faith*, I described my predicament:

> It only took reading a few court cases to open my eyes to the fact that, for the most part, the law was created because people are apt to do whatever they can—even taking advantage of their neighbor—to get ahead. Our legal system is so vast and complex because people do a lot of bad things to

each other and the law has to cover all of the angles. My optimistic bubble was quickly deflating and the truth was depressing. I soon realized that I simply hated everything about law school and wondered what in the heck I had gotten myself into.

Instead of trying to fit in this negative environment, like a square peg in a round hole, I withdrew. For me, there had to be a better way! Now bear in mind, I studied and went to class like other students, but as soon as class was over, I was out of there! I did not study or hang out at the school building or associate with other law students (except for a few close friends). I left school at school. Instead, that first semester, I devised a system in which I awoke at 4:00 a.m. and prepared for classes beforehand, which involved reading multiple cases and preparing outlines.

After class, however, I bailed out of the school as fast as my two legs would carry me, escaped to the great outdoors, and found much needed relief from the pressure. Moscow happens to be in the heart of the Palouse Prairie, which is a wildlife cornucopia. Unlike Southern Idaho, this highland prairie receives an average of 32 inches of precipitation each year and is known as one of the most fertile dry farm (no irrigation necessary) wheat producing areas in the nation. Indeed, this landscape is known for the rolling wheat fields as far as the eye can see. But for me, I sought out those areas that were untouched (or less touched) by the plow. The harvests that I was interested in were the abundant whitetail deer, elk, bears, pheasants, quail, ruffed grouse, spruce grouse, Hungarian partridge, chukars, turkeys, and certainly not least, fish. I felt like a kid in a candy store and it was definitely hard to focus on school when this smorgasbord of outdoor goodness lay before me.

During this time, one of my favorite afternoon forays was hunting ruffed grouse, but I was not yet a grouse hunter. Before moving to northern Idaho, I talked my dad into letting me bring his old Coast to Coast hardware store pump 12-gauge shotgun with me to law school, but I did not yet have a bird dog. Early that September, I hunted with my older brother Shawn, our wives and Shawn's pointer, Gibbs, in Deary, Idaho, on some private property loaded with ruffed grouse. I vividly remember taking my very first grouse off a tree limb. My sensitive wife, Kristin, cried at the grouse's demise, but I was so excited to hold one of these beautiful birds in hand. I had no idea that this was not sporting. I was oblivious to the deep tradition of hunting the ruffed grouse or of the ethics of a true sportsman.

In the weeks that followed, many days after school, I threw my shotgun into the old rattle trap Geo Tracker and headed east to Deary, where I

would walk the woods for a few hours in search of grouse, which were more plenteous that year than I have seen before or since. I had great success shooting sitting grouse that I found along cattle trails and abandoned logging roads. I felt like quite the hunter as the body count stacked up.

The more time I spent in school, the more I cherished the peace of the outdoors. I recognized a stark contrast between these two environments: the former was so stressful, negative and contentious; and the latter was so peaceful and positive, with an underlying order that appealed to all my senses. Soon the atavistic desire to kill and possess subsided some, and I began to seek a new approach.

One of my very favorite areas to hunt that fall was the University of Idaho Experimental Forest east of Moscow Mountain. The grouse were so plentiful there that you couldn't drive down the road in the afternoon without seeing numerous grouse right along the edge. My favorite covert to hunt, however, was along this trail that wound through some of the best grouse cover I can recall, and the walking was easy. Over those weeks, I never went there without seeing and taking a few birds.

One afternoon in late September, as I walked this covert, I thought that it would be more of a challenge if I took one of these thunderous birds while it was flying. I realized any oaf could take a bird sitting on the ground. As I walked toward a narrow clearing, I observed a ruffie flying low across the trail opening. I swung, shot and dropped the bird. As I picked it up, I can honestly say that I felt more pride in that one bird than all the others I had taken home earlier that season. After that bird, however, I missed more grouse on the wing during law school than I can count. But I gained a love and respect for Ol' Ruff and his wiles that remains to this day.

As I wrote in *Heaven on Earth*, this happened around the same time that my addiction to fly-fishing took hold. I recognized fly-fishing as a more challenging, graceful way to fish than the bait dunking and hardware chucking that I grew up on. At the same time, I independently came to realize that wingshooting with bird dogs was definitely the more sporting way of hunting. I'm sure this was no mere coincidence, but why?

Burton Spiller said it best in his book *Fishin' Around*: "I believe that the intimate contact with nature which all fishermen [and I would add grouse hunters] enjoy works a change in the inner man, and makes of him a humbler and wiser person." In other words, when we immerse ourselves in the great outdoors, Nature and Nature's God can teach us that there is a better way, not only in hunting and fishing, but also in life.

Chapter 3
GROUSE-HUNTING LAWYERS

The minute you read something that you can't understand, you can almost be sure that it was drawn up by a lawyer.
—Will Rogers

Everyone loves a good lawyer joke. Most recently, my good friend Scott Johnson laid this one on me: "Why do they bury lawyers twelve feet under instead of six? Because deep down they're really good people." Contrary to popular opinion, not all lawyers are bad. No doubt, many lawyers get a bad rap because of the behavior of a few.

I'm an attorney by profession, but don't hold that against me. I must admit, however, that at times, my profession and my outdoors passion seem to be completely contradictory pursuits at opposite sides of life's spectrum. On the one hand, in the outdoors there is beauty, excitement, positivity and peace. On the other, in the legal profession, there is contention, stress and negativity. Some days, because of my incessant desire to hunt and fish, I feel like a walking contradiction.

As an attorney, outdoorsman and lover of good literature on bird hunting and fly-fishing, I have enjoyed reading about other attorneys with a passion for grouse hunting. Surprisingly, I've come across quite a few.

One of my favorite stories about grouse-hunting lawyers was penned by Ted Nelson Lundrigan, another grouse-hunting lawyer from Pine River, Minnesota, who wrote extremely well about this subject. In his first book, *Hunting the Sun: A Passion for Grouse,* Lundrigan shares the story of

discovering the pocket watch and favorite honey hole of another grouse-hunting attorney from his town who had passed away many years before Lundrigan began practicing law. Of this attorney, Lundrigan writes:

> *There had been only one (other) bird-hunting trout fisherman of note in my village. He was a lawyer, like myself, only now dead. A picture of him standing in front of a string of assorted grouse, ducks, prairie chickens, and woodcock was the sole remaining mark of his presence. My father, also a lawyer, came to this town at the end of the man's career. Years later I found some documents drafted by the man and walked down the hall to ask my father if he had known him.*
>
> *"Yes, I did," he replied. Then he added as an afterthought, punctuating it with a long puff of cigarette smoke: "He could never really bend his mind to the law, but, on the other hand, he killed a helluva lot of birds."*
>
> *Yes, I thought, and the Law, sir, is an ass.*
>
> *There was a small slot on the back of the watch, just enough for a fingernail to pry up the cover. It popped open with a snap.*
>
> *"E. Howard Watch Co., Boston," it said in a line of block letters around an inscribed circle. In the middle, written in engraved script, were the words, "To Eugene, from Father, July 15, 1912."*
>
> *It was his…*

As an attorney and a grouse hunter, this story and Lundrigan's blunt description of the practice of law really resonate with me. The practice of law can be so negative and stressful that I—like these small-town lawyers—often struggle to bend my mind to it. As with these attorneys, grouse hunting and fly-fishing have become my personal escape from the hardship of the practice of law.

In his third book, *A Bird in Hand*, Lundrigan writes about how he came to grips with his profession:

> *I am an attorney. I sell time: it takes a certain amount of my time to solve a problem, and I get paid for that time. Then, I spend the money I have earned to buy time to do what I love. Getting a fair barter, value for value, is what I seek. I spend time looking for good bird covers. In return, I receive good hunting. The price is a certain amount of my life, but the value is many times greater. On the other hand, if I am in an unfamiliar area I might buy the time of a guide. I spend the money, he gains the revenue, and I learn the country and, very likely get some birds as a bonus.*

The Heartbeat of the Woods

So, whether it's time or money, public or private land, wild or tame birds, ultimately it is about one thing: a bird in hand.

Lundrigan sees his chosen profession as a means to achieve a desired end, which is to pursue his bird-hunting passion. This helps me put my seemingly contradictory profession and love of the outdoors into the proper perspective.

Roderick L. Haig-Brown of Vancouver Island is probably best known for his books about fly-fishing in British Columbia. Haig-Brown was a judge of the Provincial Court of British Columbia and was presumably an attorney before that. Less known about Haig-Brown is the fact that he was also a passionate ruffed grouse hunter. In his book *A River Never Sleeps*, Haig-Brown writes:

> *In October it is more difficult to forget the gun and remember the rod.... October has the little ruffed grouse, live red-brown among the fallen maple leaves, a crafty woodsman when he is on the ground, leaping instantly into flight when flushed, turning and twisting among the trees that are almost sure to be all about. For nearly ten seasons now I have hunted ruffed grouse over black Labradors, and they do the work beautifully, working close in and thoroughly, never tiring, steady to shot and wing.*

Haig-Brown's comments about ruffed grouse give the distinct impression that he was a lover of the noble game bird. Grouse hunting was a wonderful break for this great man of the legal world. Like Haig-Brown, many grouse hunters love to fish, but when hunting season is in play, their focus shifts entirely to the grouse woods, and they generally prefer to hunt birds with their dogs. It's good to see that I am not the only one.

One of the all-time greatest books on the pursuit of ruffed grouse has to be Grampa Grouse's (Gorham L. Cross) *Partridge Shortenin': Being an Instructive and Irreverent Sketch Commentary on the Psychology, Foibles and Footwork of Partridge*

Idaho Ruffed Grouse Hunting

Hunters. This book was first privately published in 1949, and since then, there have been only two limited reprints. I borrowed this book from Shawn a few years ago and read it multiple times before I reluctantly returned it. This book is a true classic on grouse hunting, and it's a shame it is not more readily available for the literary grouse hunter.

I recently found a copy of the first reprint of this book for fifty-one dollars on Amazon and snatched it up that very moment. As I reread *Partridge Shortenin'*, I was struck by the fact that Grampa Grouse's father was a grouse-hunting attorney. Grampa Grouse began this chapter about his family with the statement, "As the twig is bent, so is the branch inclined." Of his father, Grampa writes:

> *Birds must have been easily come to at the turn of the century, for father always wore business suit and shoes. Considering the weight of the gun and the fact that Father declared he never carried it with hammers cocked, it was probable that partridge lay in broods in the orchards and sugar bushes and if you cocked for one and had no time to shoot, another would get up in a minute.*
>
> *We would rise early with Father and ride horse cars to the Ontario and Western Railroad station to see him off on the early milk train for his boyhood home at Oriskany Falls. Here for a day he would renew his youth with the partridges and sundry boon companions with whom he had gone to country school, and who like to get "Monte" Cross out for a hunt. He would be back on the D.L. & W. (Delay, Linger & Wait) "Cannonball" that night and on Sunday we would have partridge for dinner.*
>
> *Father was a dignified and respected Attorney-at-Law and despite his generosity and humorously twinkling eye we never realized what an unmitigated barefoot hellion he had been while growing up on the Oriskany hills until later visits to Grandfather and meetings about the village with Father's cronies turned up the testimony.*

Upon reading this, I found it interesting that Grampa Grouse inherited his proclivity to hunt grouse (and to raise a little hell, for that matter) from his grouse-hunting attorney father. Grampa's irreverent book on grouse hunting is just plain fun and really captures the excitement and joy of the hunt. As with Grampa and his father, a good grouse hunt really brings out the kid in all of us. I love *Partridge Shortenin'* because it shares this aspect of the hunt better than any other book on the subject. Unquestionably, an attorney was influential to this man and his grouse-hunting masterpiece.

The Heartbeat of the Woods

Last but certainly not least, Burton L. Spiller, the "poet laureate of grouse hunting," wrote in his very first article, "His Majesty, the Grouse," about a grouse-hunting lawyer he came across in his younger years. Before meeting this attorney, Spiller confessed to being part of an "ungodly triumvirate" of market hunters, which he hunted with for two seasons before he voluntarily severed his connection with them. The following season, Spiller ran into the man who would change his life for the better forever:

> *I had been in a law office since the previous fall. The young attorney there, for some obscure reason, had taken a liking to me, as we say in Maine, and I owe him a debt which I can never repay. In addition to teaching me a few fundamentals of law he opened up for me the rudiments of literature, and delicately, by example, showed me the difference between a sportsman and that reprehensible thing I was fast becoming. He was the first man I had seen who could look down on a beaten salmon and say, "Well, old fellow, you put up a fine fight. You gave me everything you had." Then, he released the hook: "Au revoir. Perhaps we'll meet again next year."*
>
> *Gradually his influence had its effect. I bought a registered bird dog and became a sportsman.*

Not to overstate this, but from these two small paragraphs, it appears that lovers of Burton Spiller and his books about the noble ruffed grouse and fly-fishing owe a great debt of gratitude to an unnamed attorney and sportsman who taught Spiller about good literature and what it means to be a sportsman. Undoubtedly, this attorney had a huge impact on one of the greatest outdoor writers of all time.

After reading this chapter, some may think: *So what? Who cares about grouse-hunting attorneys?* I, for one, care because it is always good to find common ground with others so that you know you are not alone. I believe that anyone with a stressful job who finds solace in the grouse woods should be able to

relate to these lawyers who did the same. Grouse hunting is one of the most peaceful endeavors around, not to mention that it's just good fun.

Lastly, I think this exercise is good for the preservation of the great history of grouse hunting. As you can see, grouse-hunting lawyers wrote, influenced or inspired some of the greatest outdoor literature of our time. That's got to count for something.

So, my friends, the next time you are tempted to condemn all lawyers, remember that there are a few out there who were or are members of this great grouse-hunting fraternity to which we all belong.

Chapter 4
GROUSE AND APPLES

Never pass an old apple tree in the woods without expecting a bird to come out from under it. They eat the windfalls, and they are particularly fond of apple seeds.
—Raymond P. Holland

As a young kid, I always loved the story of Johnny Appleseed and the Disney cartoon on this American legend, especially the song: "Oh the Lord is good to me, And so I thank the Lord…" There was just something special about a man who felt it was his God-appointed calling to plant apple trees out on the American frontier. And what's not to love about apples? They are the quintessential fruit of fall.

When I first started pursuing ruffies in northern Idaho in the fall of 1998, I never dreamed there would have been a connection between grouse and apples, but this was before I knew anything about the rich history of ruffed grouse hunting. That fall, however, I repeatedly found grouse by an old apple tree near the crumbling cement foundation of a home long gone. I always thought that was a weird place for a ruffed grouse to be, given the fact that the nearest protective cover was about thirty yards away. Notwithstanding, the birds just could not resist the fallen fruit of this tree, even at the risk of their own safety (not from my poor shooting at the time, mind you). I soon learned to be on alert whenever we came across apple trees while hunting grouse.

Idaho Ruffed Grouse Hunting

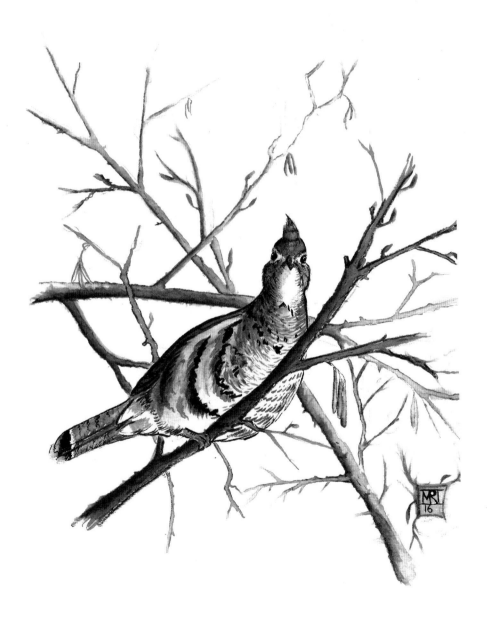

Fall Grouse by M.R. Thompson. *www.uplandart.com*.

The Heartbeat of the Woods

As I later began to immerse myself in the literature of ruffed grouse hunting—especially from back east where the grand tradition began—I found that the books are replete with references to secret coverts consisting of abandoned homesteads that the forest has reclaimed, with stone walls and overgrown apple orchards that the ruffed grouse use for cover and food. Given my experience in northern Idaho, I could relate to descriptions of such haunting, birdy places and desired to experience such tantalizing coverts. I quickly realized that no matter where you hunt them, grouse and apples go together. Once I even met a grouse hunter from back east who had named all of his English setters after different kinds of apples, which I thought was appropriate.

Nowadays, I live in southeastern Idaho, and there are hardly any apple trees near the quakie-covered mountains and draws where I pursue ruffed grouse. However, for me, the connection still remains. As the apple is the quintessential fruit of this season, the ruffed grouse is the very essence of fall: it is both beautiful and fleeting. Also, as the first hard frost comes, the apples around here take on a crisp sweetness that they did not have before. Likewise, hunting for Ol' Ruff just gets better with onset of the cold. And lastly, I always carry a few apples in the pocket of my Filson game vest while I traverse the grouse woods. In fact, one of my favorite rituals is to take a seat on a downed tree—with my smiling bird dogs beside me—to bask in the Indian summer sun and bite into a delicious homegrown apple. At such times, I've contemplated changing the words of the song to:

> *Oh, the Lord is good to me*
> *And so I thank the Lord*
> *For giving me the things I need*
> *Like the Sun and the* Ruff *and the Appleseed*
> *The Lord's been good to me.*

Chapter 5
STILL HUNTING

Guns don't kill grouse. Legs kill 'em.
—Frank Woolner

Many grouse hunters have written about the joys of grouse hunting without dogs. In fact, William Claflin Jr. argued that this is the best way: "I will admit that I have killed partridges over a point and liked it. But when I travel through a partridge cover I prefer not to have a dog along. I guess the simple answer is I am more interested in partridges and the country they live in than I am in pointers or setters."

Like Claflin, I love grouse and the country they inhabit. But I must say I concur wholeheartedly with the statement that Ben O. Williams said along the lines of: "Bird hunting without a dog is like playing football with only one team; there's not much going on."

Admittedly, there have been grouse hunts when my dogs were a liability rather than an asset and I have been forced to pursue grouse on my own. During law school, I had an Elhew Pointer named Farley (or sometimes Farles) that, in his three years of life, turned into one of the finest bird dogs I ever hunted behind. I later dubbed him the "White Wonder." But he wasn't always that way.

The start of my third year of law school was also Farley's first hunting season. My wife and I lived in Deary, Idaho, and the property we lived on was four hundred acres of some of the best ruffed grouse habitat you can imagine. Our landlord, Craig Dalton, had cut pathways through the thick

The Heartbeat of the Woods

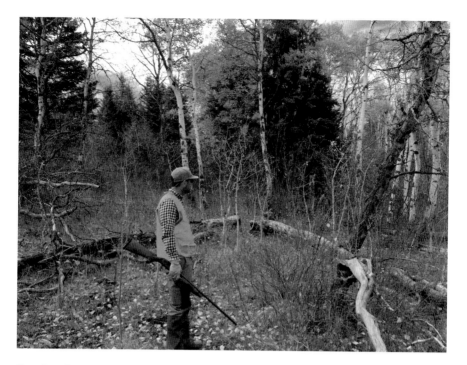

Sam Smedley admires the scenery in the grouse woods.

forest, and his grazing cattle thinned other areas such that the property was covered up in the thick, diverse edges that ruffies love, along with stands of older pines. It was not uncommon to see twenty ruffed grouse in an hour or two. Back then, they usually burned my biscuits, but we always had a riot hunting them.

Craig was also fond of hunting ruffed grouse, and one day, he agreed to hunt his property with me and my alleged new "wonder dog." We crossed over the metal gate and then headed down the two tracks to the first pathway cut through the pine patch to our right and followed a cattle trail. Within ten minutes, Farles went AWOL, and I yelled myself hoarse trying to call him back. Yes, he was a *wonder* dog all right; I *wondered* where the hell he had run off to!

Craig and his boys kept hunting the grousey property along the rim of the deep Potlatch Creek Canyon while I decided to go look for my crazy dog. Rather than stick to the trails, I cut across this hilltop that had been logged about five years earlier. The service berry trees had sprung up and were about head high.

Idaho Ruffed Grouse Hunting

Misty points a ruffed grouse in the middle of an old logging road.

I thought to myself: *If I were a ruffed grouse, this is where I'd be.*

No sooner had I thought this than I looked into an opening between two service berry trees and spied a ruffed grouse standing in the opening. I then walked briskly toward the bird, and it got up flying straightway through the little opening right where I anticipated. I dropped the bird as if I had been

doing this all my life. I must say that despite the lack of a bird dog, taking this bird was extremely satisfying because I had read the cover perfectly, I had predicted the direction the bird would flush and I made the shot. I understand men like Claflin and Frank Woolner's draw to still hunting.

This and a few other disastrous hunts with Farles led me to buy an Innotek electronic collar from Cabela's to try and rein this crazy puppy in. I'm happy to report that a little electrical persuasion—or Edison medicine, as Shawn calls it—was just the ticket to harnessing Farley's potential as a bird dog and to get him to hunt for me.

I have fond memories after law school hunting near Sublette atop this quakie-covered ridge with my brother-in-law Scott Turlington. That day, Farley pointed at least two of the ruffies that Scott harvested. I came home birdless. Even though my shooting remained sketchy, Farley really improved as a grouse dog. To this day, I consider him one of the finest bird dogs I have ever seen. In his three hunting seasons, my family and I shot most of Idaho's upland game species over Farley's stellar points. Farley's life was cut short by a car in August 2003 only weeks before the hunting season. I was devastated. I used to think that my dad, brothers, nephews and friends loved to hunt with me while Farley was alive, but I later realized it was *always* because of Farley. He was something else. I may as well have been chopped liver.

So, as to my final verdict for still hunting, I do not begrudge any person who wants to hunt this way. It is fun and challenging. However, I would rather hunt grouse with a mediocre dog—even a sometimes bird-bustin' dog like my pointer Dusty—than alone any day. In this instance, the means is just as important as the end. For me, a grouse harvested over a dog's point is the very height of sporting endeavor.

Chapter 6

WESTERN GROUSE DOGS

Outside of a dog a book is a man's best friend.
Inside of a dog it's too dark to read.
—*Groucho Marx*

So many writers have written about what they consider to be the ideal dog for ruffed grouse hunting. Historically, English pointers and setters tend to get the most votes. I've hunted grouse behind both, and no doubt, they typically are excellent breeds for pursuing ruffed grouse, but I've also hunted behind some mediocre dogs from these breeds (no offense, Dusty and Gilly Bean).

The truth is I have hunted grouse behind numerous breeds—German shorthaired pointers, English pointers, English setters, Labrador retrievers, field-bred English cockers, German wirehaired pointers, French Brittanys and American Brittanys. I have enjoyed all of these breeds and have seen some first-rate bird dogs in each.

Truth is, I am a huge closet fan of the Labrador retriever. I have hunted with quite a few Labs, and they were some of the finest hunting dogs I've ever seen. My buddy Matt Lucia's black Lab, Logan, was one of the best. I'll never forget when Matt hunted Craig Dalton's place with me in Deary, Idaho. In September 2000, I invited Matt to come out to hunt with me on the awesome cattle ranch I had the good fortune of living on at the time, a veritable paradise for the outdoorsman. Our quarry that fall afternoon was the evasive ruffed grouse. Matt, our dogs

The Heartbeat of the Woods

and I hunted along an old logging road that was bordered by some thick young pine trees and berry bushes resulting from extensive logging that had taken place years before on the property. The covert supported some of the best ruffed grouse habitat I have ever seen, and the birds were present in astounding numbers.

As we worked down the overgrown logging road, Matt veered off to the right into the thick cover when Logan suddenly showed some interest in the enticing scent blowing from this direction. Only moments later, I heard two distinct shots.

"Did you get one?" I hollered.

"I just got a double," Matt answered matter-of-factly.

Matt had just pulled off a feat that many hunters never accomplish in a lifetime: a double on ruffed grouse, and in the thick timber to boot. Matt's stellar shooting ability speaks for itself, but Logan's performance was equally impressive to this newbie bird hunter. There were not many downed birds that Logan did not find and retrieve to hand during his lifetime. I miss that wonderful dog.

And then there was Scott Johnson's chocolate Lab Gunner. Although he was a little bigger than Matt's Labs and tended to overheat in the early season, no dog loved to hunt or retrieve grouse more. I've written about Gunner and his excellent retrieves a few times in this book. In the early fall of 2014, Gunner unexpectedly passed. He is now buried in one of our favorite grouse coverts that we dubbed "Gunner Creek" in his honor. I will always have a special place in my heart for Gunner. I have to admit that there is some merit to Gene Hill and Worth Matheson's assessment: "Gene Hill got it right when he wrote something along the lines of when are people going to admit that the Lab is the best breed of them all."

I have a friend Gary Bauer from Ennis, Montana, who has a kennel full of Gordon setters and one English setter that thinks she is a Gordon. Gary field trials his dogs and primarily hunts Huns in Montana and ruffed grouse in Montana and Idaho. I was amazed to learn that Gary took forty-six ruffies in 2013 and thirty-five in 2014. This is no hype, as I saw voluminous photos of Gary's Gordons on point on Facebook both years. Gary expects nothing but the best from his Gordons and once told me that he doesn't tolerate shoddy bird work from his dogs. I am a little hesitant to hunt with Gary, as my Brittanys are good, but they have been known to bump a bird or two (or five) now and then, and that's okay with me. I'm going to make it happen because I'd love to see those Gordons at work. Maybe they can teach my Brits a thing or two.

Idaho Ruffed Grouse Hunting

Gunner makes a nice retrieve of a ruffed grouse from Grouse Springs.

I can't broach the subject of grouse dogs without mentioning my brother Shawn's field-bred English cocker spaniel. Ellie has to be one of the most fun dogs I've ever hunted with. Cockers attack cover with reckless abandon. Our friend Julian Schmechel from the United Kingdom hunts with cockers, and he once wrote to Shawn that cockers were bred in Wales by the devil himself for when he wanted to hunt woodcock. If you doubt this legend, just look at the flaming fire in their eyes.

The great author Tom Davis wrote in an article in the fiftieth-anniversary issue of the *Ruffed Grouse Society Magazine* titled "Were the Good Old Days That Good?": "I've hunted grouse successfully and enjoyably behind Labs, goldens, and springers—and I'm here to tell you that in terms of sheer unremitting excitement I know of nothing that can match the experience of hunting grouse (or any other game bird, for that matter) behind a keen cocker spaniel. These little dynamos don't attack cover; they shred it." Before I read this article, I had the opportunity to hunt with Tom Davis for a week in October 2013 and was intrigued when he opted to leave his English setter, Tina (a first-rate bird dog), in the kennel so that he could hunt with

Shawn and Ellie in Grouse Rock, one of my favorite grouse coverts. Now I understand why.

During our annual hunt in October 2014, ruffed grouse were hard to come by in some of our coverts. Shawn, our friend Kevin Swallow and I stopped on a pine-crested ridge flanked on all sides by quakie patches hoping to find a few grouse. Brother Shawn opted to take Ellie, and we all split up and hunted in different directions. As I made my loop along the ridge and through the timber and started back toward the vehicles, I heard one decisive shot in a quakie patch below me. I made it back to the truck before Shawn, and he soon approached with a smile on his face.

Shawn reported, "Ellie and I were making our way back to the truck up the dirt road when I saw a fresh grouse turd on the edge of the road. I stepped back into the cover, and Ellie then hunted through the surrounding area. Ellie became noticeably birdy as she blazed through the cover and flushed a grouse into a nearby quaking aspen at eye level. As I approached, the ruffie gave me a perfect straightaway, which Ellie retrieved almost as soon as it hit the ground." Now that is a grouse dog, my friends!

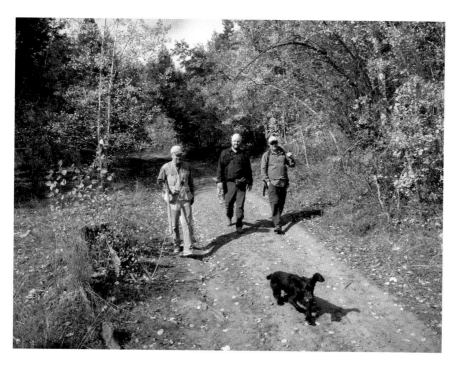

Author Tom Davis, photographer John Loomis and Shawn Wayment follow Shawn's cocker, Ellie, in the grouse woods.

No doubt, a cocker's enthusiasm for the hunt is infectious. My only criticism of the breed is that they are a one-man dog and only have eyes for their master, which admittedly makes me a little jealous, as it would be fun to take a bird every once in a while over this little black tornado with her eyes aflame.

Last but certainly not least, while I have hunted grouse with numerous breeds, I have grown to love Brittanys, both Americans and their French cousins (Epagneul Breton). I really like their bid-ability and companionship both in the field and at home (although my Misty can be quite a handful at times). I'll be the first to admit that English pointers and English setters often have a stronger pointing instinct, but for me, this does not detract one bit from the breed. Michael McIntosh, a lifelong Brittany lover, so aptly wrote, "A Brittany is fire and silk; if the fire doesn't burn quite as hot as in some other breeds, and if the silk is rather softer, what of it? That's their charm. That's why I love them so."

My idea of the perfect grouse dogs are two Brittanys—one French and one American—hunting a brushy hillside interspersed with thick quakie patches.

Misty, an American Brittany, points a ruffed grouse in the Outhouse while Sunny, an Epagneul Breton, honors her point.

The Heartbeat of the Woods

The French hunts close and keeps me company while we work a cattle trail through the timber. The American burns through the outlying areas with her bell tinkling music in the silent woods. The American's bell suddenly is silent, and the French Brittany and I quickly make our way to where we last heard it. I soon see the American locked up on point, and the older French quickly steps in and honors her kennel mate, thereby completing the triangle that points to the hidden quarry. I never tire of this sight, and it nearly brings tears to my eyes every time. I think of taking a photo to memorialize this forever, but I really want to do my part to bring the bird to hand for the dogs, so I decide against it. I step forward, the grouse thunders up straightaway, the gun comes up so instinctually that I hardly notice pulling the trigger or the sound of the shot. The bird drops, and the old French gal—who loves to retrieve more than anything in this world (except maybe me)—brings the bird to hand. That, my friends, is what it is all about.

To sum it up, as far as landscapes go, the West is about as diverse as it gets—not to mention that Idaho alone has eight upland game birds, including five native grouse species. Should it be any wonder that the bird dog of choice for grouse hunters may be just as varied and diverse? I begrudge no man or woman for choosing a different breed than mine for hunting ruffed grouse. In my humble opinion, the best grouse dog for the western grouse hunter is the one that makes you happy and gets it done. In fact, I welcome the opportunity to see anyone's dogs at work on this special game bird.

Chapter 7
COVER OR COVERT?

I will trust in the covert of thy wings.
—*Psalms 61:5*

With grouse hunters (and all upland bird hunters, for that matter), there is always a question (I wouldn't call it a debate) of whether to call our favorite hunting spots "covers" or "coverts." I've always preferred the word "covert" but wasn't sure why until just recently.

For me, the word *cover* has always meant the actual vegetation the birds use for food and protection. When a place looks like it might hold birds, I've often said, "Man, that looks like birdy cover." Whereas, the word *covert* has come to mean those secret places where I have reliably found birds in the past. In other words, a location is not a covert until the dogs and I have found some birds therein.

In his book *A Grouse Hunter's Almanac: The Other Kind of Hunting*, Mark Parman does a great job capturing the distinction between the two terms:

> *Referring to their spots, grouse hunters use cover and covert interchangeably, as if the t made no difference. Cover is the place where animals, people included, can hide, a place offering protection and food, which in the case of grouse means the tangle brush hunters must contend with, the thickets that rip off hats and bloody dogs. It's the flora every grouse hunter must learn to read: those patterns of brook and tag alder, the edge covers where popple meets red oak, the thorn apples way back by the river just past the marsh grass and aspen aged to perfection....*

> *Covert, however, means "marked by concealment, hidden, secretive." To the grouse hunter a covert conceals birds, and if it happens to conceal a lot of birds, hunters get covert (a sometimes difficult task in a state where most of the grouse and woodcock hunting takes place on public ground). We get abnormally possessive about our coverts—we name them, we start calling them ours, and then we get mad when someone else hunts there. In our minds we "own" them.*

No doubt, we grouse hunters are very secretive and protective of our coverts for all those reasons.

May I suggest, however, another reason for the use of the term by some grouse hunters? To introduce this, I want to share a quote from Charley Waterman from *Hunting Upland Birds* about ruffed grouse hunters:

> *The tradition of the American ruffed grouse has been abuilding for three hundred years and has grown mainly in the Northeast, where the ruff may not be plentiful as elsewhere but it is sought by the cream of upland hunters with fine guns, tireless legs, and love.... They also write endless of it, buy each other's books, and refuse to compare it with any other game. An outsider like me might enjoy poking a little fun at their devotion, but I am engrossed in almost any ruffed-grouse literature I find, having read Frank Woolner's* Grouse and Grouse Hunting *three times, and envy them their lifetime contact with the bird. Their attitude is one of unabashed sentimentality (rife among many upland gunners anyway), and it would be pleasant to be one of their cult. My principal object of sentimentality is the Wilson's snipe, in which I seem to be nearly alone, and if ruffed-grouse shooters will be nice to me I will be nice to them.*

Wilson snipe? This is classic Charley Waterman! He definitely marched to the beat of his own drum. As an admitted outsider looking in, Waterman compared grouse hunters to members of a cult with a religious-like zeal. And I think most grouse hunters would not disagree with this assessment, which leads to my point.

The other day I was reading in the Bible (yes, I do this regularly) and came across the following scripture in Psalms 61:5: "I will abide in thy tabernacle forever: I will trust in the *covert* of thy wings." The word *covert* instantly leaped out at me. Before this, I did not realize that this word appeared in the Bible. After reading this, however, I found that *covert* is used a total of nine times in the King James Version of the Bible, and in

each reference, the word connotes a place—oftentimes sacred—of hiding, protection or refuge.

With this religious connotation in mind, I submit that many grouse hunters—including myself—use the term *covert* because they consider them as almost-sacred refuges where they resort to escape the stressful, workaday world and to commune with Nature and Nature's God, places where the miraculous just might happen. Grouse hunters are secretive and protective of their coverts because they do not want to "cast their pearls before swine," so to speak. In other words, they realize that if others discover their coverts' true worth, they might abuse, deplete or destroy the very things that they love about them.

Pardon the cliché, but in my humble opinion, the term *cover* just doesn't seem to cover it.

Chapter 8
GROUSE SPRINGS

Hope springs eternal in the human breast;
Man never is, but always To be blest:
The soul, uneasy and confin'd from home,
Rests and expatiates in a life to come.
—Alexander Pope, "An Essay on Man"

In ruffed grouse hunting, sometimes a place becomes almost as important as the birds themselves. This is especially true the longer you hunt. I have been hunting a place I call "Grouse Springs" for over ten years now, and it has become one of my favorite grouse coverts. The first time I hunted it, I recorded in my journal, "Ever have one of those days of grouse hunting when you can't miss? Me neither, but Wednesday September 8, 2004, was a pretty good day." Before I get ahead of myself, however, let me start at the beginning.

After my two-year judicial clerkship in Hailey, Idaho, I moved to Idaho Falls in August 2003 to start my profession as an attorney. That fall, I did not have any time to find new places to hunt, so I mostly traveled long distances to my old coverts.

When the 2004 hunting season drew near, I was bound and determined to find some new coverts closer to home. I asked a friend at church, Matt Hancock—who I knew hunted—if he knew any places close by to find forest grouse, and he generously agreed to show me a spot the following day, Labor Day, Monday, September 6, 2004, which I had off from work.

Matt picked me up early Monday morning, but along the way, we got a flat tire, which took some time to fix. So we didn't make it to our destination until around 10:00 a.m.

It was a blue bird day, and I observed that this locale consisted of numerous quakie-filled folds in the foothills that transitioned up to a mostly flat, pine-crested ridge. The area was totally new to me but looked *birdy* enough.

Matt and his sons opted for the small willow-lined creek and beaver meadows across the road flanked by a smaller quakie-covered hillside, whereas my dogs, Sunny Girl and Dusty, and I hiked uphill to the numerous wooded draws. With all the rain, the various wild berries were thicker in the draws than I'd ever seen. The white snowberries were as big around as Indian head nickels. And to my delight, the near impenetrable quakie patches were loaded with ruffed grouse.

My Elhew pointer, Dusty, was brand new to our pack, and this was my first hunt alone with him after my brother Shawn gave him to me earlier that summer. At the time, I thought that Shawn was being generous, but in hindsight, I now suspect that he was just trying to pawn off a lemon

Sunny Grouse by M.R. Thompson. *www.uplandart.com*.

of a bird dog. True to his lifelong character, Dusty went on a bird-bustin' rampage that morning. Because of his tendency to put on such shows, we later dubbed him "Bustin' Dusty." He flushed two blues out of a sage and buck brush–covered flat, and I marked one of the blues down in a quakie patch and Sunny and I hunted it up, but when it flushed again, I flubbed the shots.

As I hiked down an alley-like trail surrounded by broomstick quakies in one of the biggest draws, I missed numerous ruffed grouse in the thick tangle. At the bottom of the draw, I spied a man-made cattle pond with another small quakie patch below it. When I passed by this patch, a blue flushed hard to my left, I hit it on the second shot and Sunny retrieved it to hand. Bustin' Dusty was nowhere around.

When I reached Matt's truck, he teased me about "World War III" going on up there in the timber due to all the shooting he heard. Notwithstanding, I was elated by my success in finally making a shot, but more so about finding a new covert close to home. I didn't know what to call this covert, and—thinking of a comedic scene in the movie *Forrest Gump*—I wrote in my journal: "We could call it 'Viet-Freakin'-Nam' because it gets jungle thick in those quakie patches."

Two days later, I was itching to get back to this special covert after work, and I invited another friend, Rob Jackson, to go with me to chase blues and ruffies. The dogs and I hunted down the same alley-like area in one of the big draws. I wrote the following in my journal:

> *I got into a decent covey of ruffs. The birds weren't too savvy, but I got them to fly out of the trees using sticks. I got two ruffs on the wing that way. It's a chore trying to throw a stick and then mounting your gun in time for a shot. The first attempt I left my safety on and obviously didn't get off a shot. We hunted some thick timber (quakies), but we—Sunny and I—caught the birds on the edge of a smaller patch. Sunny retrieved both birds and I was grateful she didn't chew them up this time....One last thing I don't want to forget. The second ruffie I hit was winged and it landed just outside the quakie patch. I marked the bird down and took Sunny over there. I couldn't see the bird, but Sunny became very birdy. She worked the scent well and retrieved the wounded bird to hand. Awesome! Dusty, on the other hand, was nowhere in the vicinity. I need to work on him.*

At that time, that was the most successful day of ruffed grouse hunting I had ever experienced. This covert was special from the get-go.

IDAHO RUFFED GROUSE HUNTING

Andy searches for grouse in Grouse Springs in late October.

The following hunting season, Bustin' Dusty was out of commission for the first part of the season because of his recent ACL surgery. So Sunny Girl and I returned to this new covert a few times without him. On one occasion in September, Sunny Girl and I found this spring-fed pool that was fenced in with a wooden post and rail fence right next to a thick quakie patch. We found numerous grouse close to the springs. As we struggled through the thick timber to the right of the springs, I spied a ruffed grouse running through the tangle. I ducked and weaved through the thick stuff until we came upon a downed tree. Sunny Girl then saw the ruffed grouse as it ran along the fallen tree, and she went on point. The nervous bird flushed hard straightaway as I approached, and I uncharacteristically made the shot. Sunny then retrieved the beautiful gray phased ruffed grouse to hand.

Due to our success in and around the springs, I later dubbed the whole area "Grouse Springs," which has stuck for over ten years. I truly love this sacred place. So do my dogs, especially Sunny Girl, who is now in her twelfth year. Every time I walk these wooded draws, so many good memories of days afield with Sunny, Dusty and Misty come rushing back.

The Heartbeat of the Woods

Unfortunately, over the years, the cattle that graze the property eventually busted down the wooden fence around the spring and stomped it into oblivion. Within the last five years, whoever grazes cattle on the property piped the spring into a guzzler that is in the open at least forty yards from the woods. As a result, the grouse don't seem to be as abundant in the nearby quakie patch, which is sad. I would not call this an improvement. Regardless, this special covert will always be known to me as "Grouse Springs."

Chapter 9

THINK TWICE ABOUT HUNTING ON YOUR WIFE'S BIRTHDAY

Behind every great man is a woman rolling her eyes.
—*Jim Carrey*

My wife had a birthday this week, and with it being hunting season, I couldn't help but recollect an experience I had eight years ago while grouse hunting on her birthday. I'm sure you will agree that's a risky proposition any way you slice it!

In early September 2005, I set out on the morning of my wife's birthday to get in a hunt before spending the rest of the day with her. As my pointer Dusty was recovering from ACL surgery, it was just my French Brittany Sunny Girl and me. The weather was heavily overcast, and the air had that distinct muggy feeling that rain was imminent. I was driving Baby Blue, my trusty Ford Escort wagon, and we headed to Grouse Springs east of Idaho Falls, Idaho.

As I drove into my regular parking place at the foot of a pine-crested flat-topped mountain, I felt a little nervous about getting out of there because of the weather.

I specifically recall thinking to myself: *If it starts to rain, I'll have to get out of here quickly because I'm not sure Blue will make it back up that steep hill we came in on.*

Grouse Springs is a series of wooded draws and sagebrush benches leading up to the pine-covered ridge. We typically look for ruffed grouse down low in the quakie-filled folds of the foothills and blue grouse up top, but we have occasionally found blues while hunting the lower draws.

The Heartbeat of the Woods

Grouse Springs is a beautiful, productive covert, which I visit a few times each year.

Sunny and I did the typical loop, checking each wooded draw, starting with the one closest to our parking spot, which I call the "Overlooked Covert," then over the sagebrush bench to Grouse Springs, the biggest of the wooded draws, and finally down a draw we now call "Grouse Alley," but back then I called it "Viet-Freakin'-Nam" because some areas are jungle thick. Sunny and I did not move one single bird throughout the whole loop.

By the time we hit the man-made cattle pond at the bottom of Grouse Alley, the bottom fell out of the lowering skies, and it started to dump—not rain—but snow, with a vengeance. Of course, my fear about getting out of there safely escalated, but I still wanted to hunt my way out despite the fact that we were getting soaked by the heavy, wet snow.

Sunny and I hiked over the sage-covered bench and dropped back down into Grouse Springs in the blinding blizzard. To my utter surprise, a big covey of five ruffed grouse flushed off the open, snow-covered hillside toward the springs. I shot numerous times, but in my astonishment and haste, I missed. When I went in for the reflush of a bird I marked down, I missed again. I was so flabbergasted and desperate that I blew the only opportunities of the day! I never could shoot that Remington Semi-Auto well. I remember feeling so disappointed in myself. Every miss back then was a blow to my fragile ego. And to make matters worse, I didn't know if I was going to get out of there because of the weather.

When I finally made it back to the car, I was soaked. I fired up Blue and turned around and nervously gunned it up the steep slippery two-track. With his front-wheel drive, Blue chugged up the hill, over the deep ruts and potholes back to the more solid road with no problems.

However, as we headed down toward Tex Creek—although the snow had stopped falling—the wet roads turned into some of the sloppiest, gumbo crap I have ever driven on. I followed in the tracks of someone who had slid all over the road. Heck, one false move and I could have easily slid off myself. Pretty soon, I caught up with some sheepherders towing their green hard-topped wagons, which look like covered wagons. With the treacherous road conditions, the sheepherders just stopped in the middle of the road and would go no farther. I didn't blame them.

I had no choice but to stop. I felt this urgency to get home to be with my wife. In fact, all Kristin wanted for her birthday was for me to bake her a German chocolate cake, which I had agreed to do. I thought to myself: *Serves you right for going hunting on Kristin's birthday!*

Idaho Ruffed Grouse Hunting

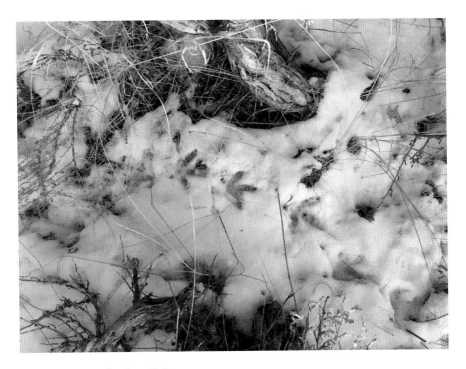

Telltale grouse tracks after a light snow.

I talked with the sheepherders for a while and assessed the situation. There was barely enough room for Blue to pass on their left-hand side, but because of the grading of the road, the road sloped down toward a ditch. At best, it was a sketchy proposition.

Desperate men in desperate circumstances do desperate things, so I decided to go for it. With the gumbo mud caked on my tires inches thick, I spun and slid on the road, but old reliable Blue stayed straight, trudged slowly forward past the trucks and sheep wagons and carried me safely the rest of the way to pavement.

I made it home without much more ado and baked my wife a cake, which she enjoyed. I often think of that crazy hunt, the blizzard in September and the harrowing roads, but I've never taken the time to write this story down until now. Since then, I always think twice about hunting on my wife's birthday. Eight years later, we are still happily married. She must love me to put up with such shenanigans!

Chapter 10

MIXED BAG

Variety's the very spice of life, that gives it all its flavor.
—*William Cowper*

One cannot read the literature of ruffed grouse hunting without reading much about hunting woodcock, "the little russet feller," as Burton Spiller fondly described them. In the Intermountain West, we do not have woodcock, but we have a cornucopia of other upland game birds, and it is not uncommon to get a mixed bag.

Idaho has nine upland game birds that you can hunt with bird dogs, namely ruffed grouse, blue grouse, sage grouse, sharptail grouse, spruce grouse, Hungarian patridge, chukar partridge, ring-necked pheasant and valley quail. While ruffed grouse hunting, I have often run into a number of these other species and have even taken home the much-desired mixed-bag on occasion. Admittedly, many of my encounters with the various bird species involve me getting jackslapped by ruffies.

During law school, Shawn and I used to hunt this covert near Troy, Idaho, we called the "Christmas Tree Farm" because it had a patch of Christmas trees planted in rows adjacent to a small pond surrounded by cattails, which the abundant pheasant of the area loved. On the back edge of the property was a hawthorn-choked ravine, and the first time we hunted it, I killed a beautiful red-phased ruffed grouse in the draw. Shawn's pointer, Gibbers, later locked up on the edge of the Christmas trees, and my ex-sister-in-law Holly killed a beautiful rooster. I missed another rooster that flushed my way.

After that first hunt, I found grouse there at other times, but they usually got the best of me.

Down the grade from Troy and up the steep Potlatch River canyon side near Kendrick, Idaho, my dogs and I used to hunt this covert I called "Madman Land" because nobody but a deranged birdbrain would ever try to hunt such a steep, gnarly place with its impenetrable thickets, stabbing star thistle and blackberry brambles. This covert had it all: pheasants, Huns, tons of quail and a few ruffed grouse up near the pines. I took a few quail and pheasant there, but the ruffed grouse used to startle me so bad, I don't recall ever getting off a shot at one.

In southern Idaho, the second most common bird that my dogs and I encounter while pursuing ruffed grouse is sharptails. I've written much about my favorite covert, the Royal Macnab, which is sagebrush steppe terrain currently enrolled in the federal Conservation Reserve Program (CRP) with three large parallel, wooded draws gouged by runoff over time. While sharptails are far and away the most plentiful bird at the Royal Macnab, there are also Huns, pheasants and ruffed grouse near the quakie-choked draws.

One Saturday in October 2003, a friend, Rob Nelson, and I were hunting sharptails in the rolling CRP fields, and a large covey flushed overhead and flew into the middle draw to an area we now call "the Pinch." We call it that because the cover in the draw narrows to a point where a game trail cuts through, allowing easy passage across the draw. For some reason, all of the species of birds on the property love this particular spot. I know because I've missed them all there at one time or another.

Of course, Rob and I pursued the sharptails, and when we stepped into the wooded draw, birds were flushing all around us. I shot one sharptail as it flushed through the trees, and then a ruffed grouse got up nearby and I missed it ingloriously. I followed it up, and if memory serves me right, I missed that darn ruff a total of four times. Another sharptail flushed in the timber, and I dropped it on the first shot. As excited as I was to fill my limit of sharptails, I felt humiliated by that ruffed grouse that thoroughly kicked my butt. Over the years, that ruffie (or its progeny) burned me and Shawn numerous times.

In mid-October 2009, Sunny Girl and I set out to hunt the Royal Macnab while ashen, glowering skies spewed rain. I was tempted to stay dry and warm at home, but we decided to brave the elements anyway. However, we could not find a single sharpie at any of the regular haunts in the CRP.

So Sunny and I hunted the tree line along the draws in the steady, drizzling rain. As we moved up the left edge of the middle draw, Sunny turned birdy

and headed toward a nearby chokecherry thicket. A soggy ruffed grouse then reluctantly hopped up onto a chokecherry limb, and Sunny froze on point. As I approached the thicket, the bird barreled out of chokecherries, and I shot at the blur through the thicket. The shot felt good, but I didn't see the bird drop. Sunny Girl charged through the sopping wet cover and after a moment returned with the ruffie in her mouth. That was our only bird for this gray day, but we still headed home in high spirits.

Probably my strangest experience of running into ruffed grouse on the Royal Macnab occurred on the opener in 2010. Sunny, Misty and I hunted up and over the main draw and then hiked down this hilltop flat where we often find sharptails. I spied a little divot in the flat that held a few sapling chokecherries in the midst of the thick CRP grasses. Thinking I might find a few sharptails, I cast the dogs into that direction, and birds started to blow out of this little divot heading for the main draw to my left about one hundred yards away. To my utter amazement, while half of the birds were sharptails, the other half were ruffed grouse—a long way from the protection of thick timber. I think I counted four ruffed grouse blazing out of this grassy flat, and I was impressed with their speedy, long-distance flights. Though I had a few really good opportunities, I missed both ruffs and sharptails with equal ineptitude. Try as I may, I could not relocate any of those crazy ruffed grouse. What brought them so far away from the wooded draws will always be a mystery to me.

In my experience, the most common game bird we run into while ruffed grouse hunting in Idaho is, by far, the dusky grouse, or "blue grouse," as it is commonly called. Like its low-land cousin the ruffed grouse, blue grouse is a grand game bird, and my dogs and I love them. For the longest time, they were my favorite gamebird, but now I prefer to hunt ruffed grouse just a hair more. Frankly, I'm glad I do not have to choose between the two of them. Blue grouse hunting in September has to be one of the best hunts of the year. In September, we often find blues and ruffies in the same coverts, but as the season progresses, blues reverse-migrate up to higher elevations, whereas ruffed grouse typically stay down by creek bottoms. Hands down, the absolute best times in my coverts are when the blues and ruffs are close to each other.

In my forthcoming book *Roadside Revelations*, I wrote a chapter titled "Idaho's Fab Four," in which I describe taking a Hungarian partridge, a limit of sharptails, two blues and two ruffed grouse all on October 9, 2012. The focus of the chapter was on taking four upland bird species in one day.

Above: A beautiful gray-phased grouse for the author's mixed bag.

Left: In October 2012, Andy took four species in one day: sharptailed grouse, Hungarian partridge, ruffed grouse and blue grouse. That is what we call a "glory day."

The Heartbeat of the Woods

In addition to accomplishing this feat, I also happened to take a limit of four forest grouse that day. You see, in Idaho, ruffed grouse and blue grouse are included as part of the same bag limit. For our last hunt, our group—consisting of me, Shawn, our friends Sterling Monroe and Troy Justensen and Troy's twins, Wesley and Brigham—planned to hunt a covert we call Grouse Rock. By the time we reached Grouse Rock for our final hunt of the day, I already had one Hun, two sharptails, one ruffed grouse and one blue grouse. So I only needed two more birds to fill my limit. I kid you not when I say this, but the road and woods seemed to be overflowing with grouse that evening. I really have no idea what brought all of the wary grouse out of hiding, but we found birds everywhere we turned. Maybe it was the moon phase.

Following is my journal entry for the rest of this epic mixed-bag hunt:

> *Troy Justensen, his twin boys, Wesley and Brigham, and I hunted up Grouse Rock. Shawn and Sterling drove over to the next draw. Grouse Rock was literally <u>loaded</u> with birds. As soon as we hit quakies, Troy spotted a ruffed grouse and walked it up. He missed his first shot, but connected on the second and Misty retrieved.*
>
> *At the park-like opening at the mouth of the draw, Misty bumped a bunch of grouse. Troy missed a few. One crossed in front of me right to left and I missed it on the first shot, swung further ahead and connected. When I walked up, I was amazed to see that it was a blue grouse because all the other birds flushed were ruffies.*
>
> *We worked up through the thick young growth and found more birds. One flushed into a tree and, after poking it with my barrel to get it to fly, I missed. Misty found another ruffie and it flushed into a tree. I pitched a stick, hit the branch it was sitting on, and the bird gave me an easy shot. I just filled my limit on forest grouse for the first time <u>ever</u>!*
>
> *Misty then located and pointed another ruffie and I called for Troy to walk it up, but Misty flushed it before Troy could get to it. We marked it down and Troy got off a shot this time, but missed.*
>
> *We worked back down to the truck and saw a few more grouse which Troy could not get a shot at. All said, we moved 10 to 12 grouse in Grouse Rock, which is great.*
>
> *Troy needed to get going so I had him drive me up to where Shawn and Sterling were hunting in the next canyon over. Along the road, we saw two grouse. I thought they were both ruffs. I handed Troy the 28 gauge and some shells. He walked the birds up and missed. I ran to him with four more*

shells and he went into the cover and reflushed the first grouse and shot it. I then heard another shot and he got the second bird. Then Troy walked back to the dirt road with two birds in hand, both blues. Shawn and Sterling had driven down to where we were and they observed the whole event.

All said, our group took: 6 sharptails, 2 Huns, 6 Ruffs, and 5 Blues. That is a Banner Day if ever there was one! So many firsts for me: (1) first limit of sharpies for the year; (2) first limit of forest grouse ever; (3) first day of taking two limits of different birds in one day; (4) first day of taking three species in a day; and (5) first day of taking four species in a day. What a day!

And we topped it off with carnitas at the taco bus.

Man, I love bird hunting in Idaho (and tacos)!

There's an old saying that "variety is the spice of life." If that's true, then there are not many places spicier than Idaho when it comes to wingshooting. Idaho offers some of the most diverse opportunities for a mixed bag.

The ruffed grouse is surely king, but he is no tyrant. There's enough room in his kingdom for other grand gamebirds. One who pursues only the ruffed grouse is poor indeed.

Chapter 11
THE END OF THE ROAD

What we call the beginning is often the end. And to make an end is to make a beginning. The end is where we start from.
—*T.S. Eliot*

On Christmas Eve 2009, as Sunny and I approached the Royal Macnab, my all-time favorite covert, we found a big snowbank—left by the county snowplow—blocking our progress. This was the end of the road for "Red Ed," my Ford Explorer, but not for Sunny and me. We hoofed it through the deep snow to the quakie-filled draws that hopefully held the object of our pursuit: ruffed grouse. By then, the sharptail season had been closed for almost two months.

Once we got off the road, we found deep snow that made it tough going for little Sunny and me, but we trudged ahead in hopes of one last encounter with a wild grouse. Beautiful, long hoar frost covered everything at this high altitude, and the frigid air was hard to breathe.

I had in mind a particular place for us to hunt, a brushy draw in which the cover narrows to a pinch. For whatever reason, ruffies and sharptail grouse love this spot, and for this reason, my brother Shawn and I love it too. We call this spot "the Pinch." In fact, in October 2008, Shawn had a wily ruffed grouse burn him royally in the thick timber near the Pinch. After this experience, he fondly wrote: "I'll be dreaming of the ruffed grouse that THUNDERED out of that aspen-choked draw of the Royal Macnab, without offering me a shot, for years and years to come!"

Idaho Ruffed Grouse Hunting

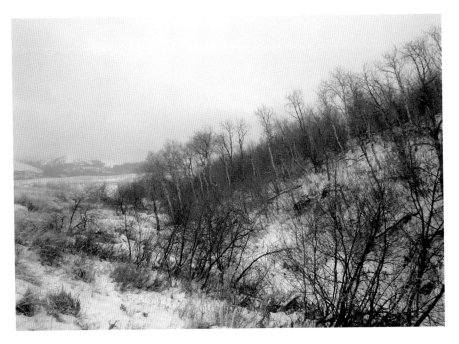

The Pinch always seems to harbor a few birds, even during the wintertime.

If the truth be told, I've been outsmarted more than once by that same bird or his ancestors. In the words of Grampa Grouse, I have certainly been tempted to *grudge* those birds, but truthfully, how can you hold a grudge against such magnificent creatures?

At the top of the draw near the inside edge of the timber, Sunny Girl, my French Brittany, became very birdy near an elderberry bush, the fruit of which had been shriveled by the sun and scattered about on the snow by the wind. This happens to be right where we always ran into the wily character, and I observed bird tracks all over. My heart started to pound heavily.

Sunny soon located the source of the scent and struck a stellar point. The picture I took of her does not do her justice. I'll never forget watching her nostrils flare as she sucked in the unmistakable, mesmerizing scent. As they often do, however, the wily bird snuck out from under her point.

With the intensity of Sunny's point, I knew the bird had to be somewhere nearby. So I stepped outside the top end of the cover into the adjacent CRP field and pushed toward where the cover narrows to the Pinch while Sunny worked the cover below me.

At the very end of the cover, the nervous bird felt the pinch, flushed not five feet from my position and gave me an easy shot as he dove back down

Sunny Girl points a ruffed grouse below an elderberry tree in late December.

into the heavy cover. Of course, it took me two shells to get the job done. Honestly, when we brought this bird to hand and as I smoothed its plumage, I felt remorse for the demise of the gorgeous grouse.

Moments like these help me to appreciate Sunny Girl. She may not be the best bird dog in the world, but I will say, without reservation, that no dog ever tried harder or loved the hunt more.

Over the years, an old, broken-down, rust-red combine on the property has served as our favorite place to take pictures of the fruits of our hunts. It seemed only fitting to honor this beautiful bird and this wonderful wintry hunt with a quick stop for photos.

The sun strived valiantly to pierce through the cloudy veil all day, but to no avail. Yet with the thrill of success and the physical exertion, I glowed with warmth as Sunny and I slowly made our way back to the vehicle. I can't think of a better way to end a season.

The sun's good-faith attempt to shine through the clouds reminded me that just as surely as day follows night, spring follows winter, and fairer days would come again. Sunny and I would be together in the uplands again the next year. Memories like these give me the hope, patience and wherewithal to wait for such future days.

Chapter 12

RUFFIN' IT WITH MISTY

It seems to me that any man who loves the grouse would have to love a dog, for these are two of his Maker's finest creations.
—*George King,* That's Ruff!

It's hard to believe, but we are nearing the end of my Brittany Misty Morning Sunrise's ("Misty") fifth hunting season. Although things started out a bit shaky because of Misty's hyper personality, she has turned into an excellent bird dog and also a good companion in the field, the latter of which is every bit as—if not more—important to me.

As I reflect on her already impressive career, I think my favorite memories with Misty are of hunting ruffed grouse together. For whatever reason, Misty just seems to *get* ruffed grouse hunting. Following are a few snapshots of ruffin' it with Misty during her first three seasons.

2010, FIRST SEASON

It's late October, and my brothers, Shawn and Robbie; my son, Tommy; his friend Mason; and I are pushing through a covert we call Grouse Springs because we always seem to find the grouse close to the natural springs on the edge of the big quaking aspen-filled draw. The dogs get ahead of us, and Sunny Girl locates and flushes a ruffed grouse into a tree. Sunny then does

Thomas Wayment and his best friend, Mason, show off Misty's ruffed grouse.

something I've never heard before: she barks in high-pitched excitement—like a Golden retriever—at the treed grouse until I can get into position.

I finally see the object of her excitement in a small quakie, a ruffie with its crest raised in alarm. I holler at the bird and walk toward it briskly, and it flushes hard into the thick cover. I snap a shot at the grouse as it tops out over the trees, but I don't see the bird go down. I think to myself, *I think I was on that bird*.

Robbie, Shawn and the boys continue to push up to the top of the draw. I decide to take the dogs and see if we can find that grouse. We follow the line the bird took. The going is tough in the thick cover, even with the leaves down, and I have to get down on my hands and knees to get through one gnarly section. When we reach a small opening, I hear the thunder of wings, but the bird only gets a few feet off the ground because its wing is broken. That's Misty's cue, and she chases down the running grouse and brings it to hand: "All right, Misty!" I praise. It is one of my proudest moments of her to date.

It's the beginning of November, and I am not ready to hang up the hunting vest yet, as it has been the best season I have had in years, which has a lot to do with Misty. Besides, this Saturday morning is blue bird beautiful. I decide to take the dogs to the Royal Macnab. Since the sharptail season is now closed in Idaho, we are looking for ruffed grouse in the thick quakies above the rolling CRP fields. We walk along a two-track road, with thick quakies on either side. The cover reminds me of many of the New England coverts I have read about in so many books, and fittingly, the fall colors are in full force.

In the midst of my revelry, Misty wanders off to my right into a thick tangle and goes on point, with Sunny Girl backing. There is no doubt in my mind that she has a bird. While my heart pounds in my chest, a bird rips up through the cover, and I promptly miss it twice.

More determined than ever, I mark the bird down and go right to the spot it landed and it flushes again, with the same result. The bird's flight is farther this time, but I think I know generally where it is. We approach the site, and I'm walking on eggshells, as I know the bird will erupt any second. The dogs and I are pushing through sage and bitter brush near a grove of quakies, and the bird gets up in the wide open. I blow two more holes in the sky, and the bird is gone.

Later that day, I post on Facebook, "Grouse 6, me 0. I got my butt kicked today in the grouse woods!" But Misty did pretty darn good.

2011, SECOND SEASON

The winter of 2010–11 had been a harsh one. The snow in the high country did not leave until early June. The long winter had taken its toll on the grouse populations. The dogs and I struggled to find many birds on opening day.

Notwithstanding, hunting is an exercise in optimism, and I decide to take off the Friday of opening week to try to find some grouse. We hunt Grouseketeer Ridge and see nothing. To paraphrase Benjamin Winiford Payne from the movie *Major Payne*, I jokingly state out loud, "There gotta be some bird need a lil' killin'!" So we head over to Grouse Springs.

The Heartbeat of the Woods

Grouse Springs has been so consistent over the years, so I still feel hopeful. However, despite a good once-over, we find no grouse in the draw where the spring flows. We hike all the way to the top of Sunrise Ridge and find no blues up top. So we head downhill to the quakie draw that runs parallel to Grouse Springs, a covert I call Grouse Alley. This is our final push for the day.

Since it's early September, the trees are dressed in full, green foliage and the cover is thick. Not to mention that it is getting hot. As we make our way down a narrow game trail, an alley of sorts, the dogs and I enter into a small brushy opening that just screams of grouse. Sunny and Misty—the old-timer and the pup—begin to work scent in unison, giving me only a moment's warning. As they zero in on the scent's source, a ruffie flushes hard through the opening, giving only a split second for a shot. I swing as hard as I can and actually shoot through some thick green leaves. The next thing I hear is the threnody of the bird's last wing beats on the forest floor. Sunny Girl brings the bird to hand. I am thrilled to the core.

This is our only bird for the whole month of September.

Despite a rough start, hunting improves in October, especially during our annual week of hunting in the Idaho uplands. Shawn and I are ecstatic about our week of hunting, as if the hunting has been better than ever before. Man, I love Idaho!

While I love to hunt quail, Huns and sharptails, the birds of my heart are ruffs and blues. So it is only fitting that we end the week in one of my best ruffed grouse coverts, Grouse Alley, where I took my first bird of the year in September with Misty and Sunny.

For years, Shawn—who lives in Colorado where you can't hunt ruffed grouse—has wanted to take a ruffie over a point but just can't seem to get it to all come together when he is in Idaho. As we walk through Grouse Alley, his little tri-color setter, Grouse River Gretchen, does what she was bred to do and finds and points a bird, which flushes straightaway. Brother Shawn snaps a shot through the cover, and the bird comes down.

When the bird is brought to hand, Shawn exclaims, "Andy, this is a red-phased grouse!"

Brother Shawn with a nice red-phased ruffed grouse pointed by his English setter, Gretchen.

I respond, "They are pretty rare in this covert. The majority of the grouse here are gray."

We continue to push down the alley, and the dogs are working the cover well. Only fifty yards from where Shawn took his grouse, Misty, no longer a puppy, crosses in front of me and strikes a beautiful point, which all bird hunters live for.

"Brother, Misty is on point!" I exclaim.

At the sound of my voice, the bird thunders right to left, and I swing hard and throw a shot ahead of the gray blur. With the thick cover, I do not see the bird hit the ground, but Shawn does.

"Good shot, Andy!" he compliments.

I am so proud of Misty that I cheer, "Yeah, Misty!"

What a way to end the week in the Idaho uplands! It feels as if the dogs and I have come full circle.

2012, Third Season

It rained hard Friday night, but I don't want to miss out on any hunting this opening weekend. My son, Tommy, agrees to come with me this Saturday morning. Fortunately for us, the sun decides to show its face and warm things up some, but everything is still soaked, and we get a little wet too. We hunt the windy ridges in search of blue grouse and find a few, one of which we take and Misty retrieves.

After a long and fruitless walk on Hope Hill, Tommy is ready to call it a day. But a diehard grouse hunter is never ready to call it quits, so I keep my eyes peeled as we head down the dirt road toward home. As we drive, I notice a ruffed grouse sitting on a bare spot beneath a big pine tree, where it is trying to get dry and warm from the wet night. There's my Roadside Revelation!

"Tommy, I just saw a bird!" I state excitedly, "I'm going after it, okay?"

"Okay, but I'm going to stay here and play on my tablet," Tom responds. Kids and their dang technology!

I pull over and climb the barbed-wire fence and hike toward where I saw the grouse. As Misty and I work through the trees, however, we don't see the bird. I am about to turn back but then think: *I know what I saw. There was a grouse somewhere in here.* So I stay the course. Ten feet farther, I spy the grouse hunched beneath a pine bow, right where I first saw him. *I knew I saw a grouse!* I call Misty over to me, point toward the bird and command, "Get the bird!"

Misty makes her way toward the bird, and it gets up and runs back the direction we came in. I realize that if I am to get a shot, I need to relocate, so I quickly back track down the game trail I came in on, hoping to see the bird when it gets up. Misty flushes the grouse perfectly right in front of me. I throw a shot ahead as it crosses in front of me, and the bird drops. Misty and I have our first ruffed grouse of the year, and I couldn't be happier.

Misty poses with the ruffed grouse she worked so well.

The Heartbeat of the Woods

Like I said, Misty has turned into a heck of a good bird dog, and to my good fortune, she excels on the wily ruffed grouse. I look forward to our future days together in the grouse woods. There is nowhere I'd rather be than ruffin' it with Misty.

Chapter 13
DESPERATE DAYS OF GROUSE HUNTING

Now is the winter of our discontent.
—*William Shakespeare*

The sweet of September and the glory of October are long gone. Even the gray, bare-bone days of November have mostly passed. All that's left of the grouse hunting season is the unkindly, frigid days of winter. This is grouse hunting in desperate times.

In Idaho, hunting in late November and December is a far cry from the halcyon days of the kindlier months. Sometimes, I wonder why I bother as it seems easier to just stay home next to the warm fire and dream about bird hunting. But the wild birds of the thicket call, and a grouse hunter must answer. Not hunting is *not* an option.

Vivid memories cloud my mind, like drifting snow in a frigid wind, as I contemplate these sometimes difficult days afield. For example, in December 2004, I hoped to find one more ruffie at Grouse Springs, a covert we first hunted earlier that fall. As I traveled along icy dirt roads, the weak sun broke through the clouds, but its light provided little warmth. As I passed numerous CRP fields interspersed with quaking aspen patches traveling farther and farther away from civilization, I became increasingly nervous. Winter hunting does that to me.

A solitary sage grouse flushed from beside the road and flew in front of "Monty"—my Mitsubishi Montero Sport—for a while. The loneliness of this massive grouse matched my sentiments as I followed it into the wintery

The Heartbeat of the Woods

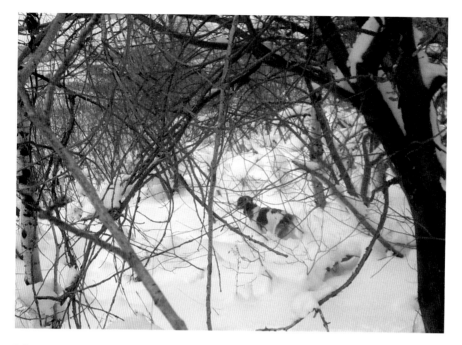

Misty on point in the snowy grouse woods.

wilderness. Never before had I seen a sage grouse in this location and never since. I wasn't sure it was a good omen.

The road traversed the mountain ridge for a short distance before it forked. I turned left downhill through the forest. To my consternation, Monty was the first vehicle to drive this road covered with at least a foot of loose powder. The trip downhill was fine, but I immediately worried about the climb back up.

I made it safely to the foothills that lead up to Sunrise Ridge, but I could not get to my regular parking place. So I pulled off the main road and hiked with Sunny and Dusty to the nearest quakie patch. The wintery woods were quiet and beautiful, but we found no grouse. I made it almost to the top of the ridge but then turned back due to the feeling I had had enough of this forsaken place—such a far cry from the beckoning and warmth of September.

When I reached the vehicle, I loaded up the dogs and apprehensively drove toward Skyline Ridge. Knowing that the road I came down on was not my best option, I tried another icy road leading up to the ridge that had more use, which compacted the snow into a sheet of solid ice. Even though I had Monty in four-wheel drive, the road was so slick that it stopped dead in

its tracks at one particular steep spot. So I backed up to get a running start and tried it again with the exact same result.

I then understood that I must drive up the snow-covered fork that I came in on. As I tried this ascent, Monty did just fine until we reached about fifty feet from the top of the ridge, where we lost our momentum in the loose powder and Monty's wheels just spun to no effect. Fear began to slowly creep in.

I had no choice but to try and back down this windy, slippery road. Fearing that I might slide off the road into the thick quakies below, I cautiously stayed as close as I could to the road's uphill embankment. My precaution, however, did me in as I slid into a little rut that runoff had washed out along the uphill side of the road. I became hopelessly stuck.

At this time, panic set in. Here I was, stuck forty miles from home in December. At desperate times such as these, so many thoughts cross your mind: *How am I going to get out of here? Will anyone be traveling this road soon? Am I going to freeze to death? Am I going to have to hike out of here? Kristin is going to be so worried about me.*

I got out of the car and let the dogs out for a minute but then put them back into the car while I hiked up to the top of the ridge to try to figure out what I was going to do. When I reached the top, I pulled out my cellphone, and—to my utter amazement—I had a signal.

I quickly dialed Kristin's number and pleaded, "I am stuck out here in the middle of nowhere. I need some help. I don't know who we can call. Will you call a wrecker and see if they will come out here and tow me out?"

Kristin was not at all happy about my predicament, but she quickly called a wrecker, called me back and reported it was going to be a whopping $500 for them to come and help. Feeling I had no other options, I told her we'd have to use the credit card. I felt so bad because Christmas was just around the corner and this was a serious financial setback for my young family.

In short, the wrecker came and pulled me out back to where the road forked leading to the other icy road I had earlier failed to climb due to the slickness. One of the men in the wrecker then put Monty into four-wheel drive low and climbed the slick road with no problems whatsoever. My problem earlier had been that I had been using four-wheel drive high, which wasn't enough. I felt so stupid.

When we parted ways, I headed home ahead of the wrecker just in case I ran into any more problems. As I moved steadily homeward, I experienced contrasting feelings: an acute sense of relief and regret, wondering why I had let my incessant drive to hunt get me into this predicament in the first place.

The Heartbeat of the Woods

Not all my late-season grouse hunts have such difficult endings. Toward the end of 2005, I asked a good friend from my undergrad, Rob Thompson—who also lives in Idaho Falls—where I could find accessible forest not far from home. He told me of a place southeast from home where I had never before ventured and even showed me how to get to the general area.

One bright December morning, I set out for the narrow canyon road. As I drove farther up the canyon, I was pleased to see thick forest on both sides of the road consisting primarily of chokecherries in the creek bottom, aspen in the foothills and Douglas firs higher up near the ridges, which is a good recipe for grouse habitat.

Everything was covered in snow that grew steadily deeper as we climbed in elevation. While the area was mostly private property, the fence along the road held numerous "Access Yes" signs, which is an Idaho Fish & Game program that allows sportsmen to utilize private property by foot access only.

Having never hunted this area before, I was forced to try to read the cover to find grouse, which can be tough in winter. On the right-hand side of the road flowed a little trickle of a creek, and in one particular area right above the creek lay a seemingly impenetrable wall of evergreens. Above the wall of pines was an old logging road running parallel to the creek with nice quakie thickets just uphill from the road.

I thought to myself, *This cover looks as good as any!*

So I parked and let out Sunny and Dusty, and we trudged through the snow, across the creek and up through the evergreen wall. When we broke out of the pine cover onto the logging road, the brilliant sun lit up the white hillside and did wonders for my psyche. It was good to be in the grouse woods.

I walked the logging road while the dogs searched the nearby quakies. Alongside the road near an ancient pine, my Elhew pointer, Dusty Boy, got birdy, and I looked down on the ground and saw fresh grouse tracks, which is one of the benefits of hunting in the snow. Dusty followed the tracks up the embankment near the massive pine, and a grouse flew hard down the valley into a quakie patch while I missed it two, maybe three times with my Remington 11-87 Semi-Auto. I never could shoot that gun well.

Hoping for a chance at redemption, we pursued and went right to where I had marked the bird down, and this time, it got up right in front of me, giving me the perfect straightaway shot, which I flubbed twice. While

frustrated at my crappy shooting, I was still pleased that we had found a new area to hunt and that we had actually found a grouse in the late season.

In future years, this area would become one of the most productive areas I have ever grouse hunted with special coverts that I would later dub Grouseketeer Ridge, Dusty's Nub, the Outhouse, Hope's Hill, the Knife's Edge and Hearth and Home. And to think, all this started with a grouse hunt in the desperate days of December.

Since getting stuck in December 2004, I generally prefer to hunt in the late season with another hunter. In late November 2006, I talked my good friend Matt Lucia into hunting grouse up on Grouseketeer Ridge, which is above the area where Dusty found the grouse the December before. This ridge had been so good to me in the early season.

That day, the mountainous landscape was, as Grampa Grouse puts it, a "veritable winter fairyland." However, Matt and I found not a single grouse. And to top it off, while we were out hunting, the battery in Matt's truck totally died, and Matt could not get it started. We even tried to push Matt's truck down the road to jump-start it, but this was no use. For all practical purposes, we were stuck on top of a mountain in December. This was beginning to be a regular occurrence for me.

Easy Pickins', one of the author's coverts, after a fresh snowfall.

Fortunately, Matt had brought the fixings for Hippie Sandwiches, which are constructed with bagels, spicy chicken, hummus, horseradish, cucumbers, spicy mustard and sprouts. Since we were on top of a mountain ridge, I had cell service. I called my wife, Kristin, and begged her to drive all the way up to the ridge top to help us, while Matt made delicious, but frozen, Hippie Sandwiches. By the time Kristin made it up to us, she was in tears wondering if we had led her on a wild grouse chase. Shortly after she arrived, we successfully jump-started Matt's truck and made it safely off the mountain.

Matt felt so bad about Kristin having to come up to save our butts that he took us out to dinner in Idaho Falls that night. After a lovely steak dinner, I jokingly stated, "Matt should get us stranded more often!" I'm sure that Kristin thought otherwise.

As if our first attempt was not bad enough, in November 2007, winter came early, and Matt and I again ventured up to the same mountain ridge for one last grouse hunt, but this time with Matt's new Toyota Tundra truck. Thus, we knew we wouldn't run into another problem with a faulty car battery.

When we arrived, at Matt's suggestion, we began hiking up the road that leads to Hope Hill, which is across the road from Grouseketeer Ridge. Within the first hundred yards, we spied a ruffed grouse standing in the snowy road. As we approached, the grouse flushed hard to some nearby quakies.

Because of how wonderfully Grouseketeer Ridge had treated me all season, I then decided to try Grouseketeer Ridge on my own, for this was the very year that this special covert earned its name. I also wanted to hunt the pine thicket below Dusty's Nub, which is the highest rounded peak in the range. So I left Matt to try my luck.

Sunny, Dusty and I found no grouse on Grouseketeer Ridge, where we had found so many earlier that season. Likewise, we did not see any in the thick Douglas firs near Dusty's Nub. The blue grouse that frequented the locale in September and October had migrated elsewhere.

The grouse woods were so quiet and forlorn that I decided to go try to find Matt. I waited for him outside his truck for what seemed like an hour while the skies spit sleet and snow in my face, but Matt did not show up.

In such situations, the mind plays tricks on you, and I started to worry that maybe something was wrong with Matt, so I set out hoping to find him.

I headed across the road and hiked long and hard in the slick snow. In a steep, dark timbered area, I slipped and jarred my back. Pain shot down my right leg, and I instantly knew that something was seriously wrong, but I kept on hiking and hollering, trying to locate my lost friend. I even fired a shot to try and get Matt's attention. Not long after I fired my gun, I heard a shot up on top of the ridge and realized that Matt was likely working his way back toward the truck along the ridge's spine.

I made it to the truck before Matt, and he soon walked up with a big smile on his face.

"I really got into them. I took one ruffed grouse and two blues and just barely missed another blue grouse," Matt reported, which explained the shot that I had just heard.

While I was out worried sick and searching for my friend, he was having a banner day of winter grouse hunting. I should have stayed with Matt!

As we drove home, I realized that something was seriously wrong with my back. The months that followed were some of the darkest and most painful of my life as I suffered from a ruptured disc in my lower back. Due to this injury, I ended up having to have back surgery in March 2008.

One would think that after such a trying experience I would never dare venture into the grouse woods during winter again, but I love grouse and the places they inhabit so much that the risk seems worth it, although I am much more careful nowadays. Besides, I've learned that grouse do some really intriguing things in winter to survive.

On Thanksgiving in 2010, Idaho was hit with a severe winter storm, and the temperatures dropped below zero while snow fell steadily for over twenty-four hours straight. I have made it a tradition to hunt over the Thanksgiving weekend, but with weather like this, hunting was not an option that holiday.

When Black Friday rolled around, the temperatures rose slightly and the snow let up. So I set out for the Royal Macnab with Sunny and Misty. The snow in the foothills was much deeper than at my in-laws' home—a good eighteen inches at least—and the going was tough, but the dogs and I slowly

made our way toward the big draw by staying close to the quakie fingers that spread across the property.

At our approach, sharptails began to flush out of the big draw in amazing numbers, and many landed in nearby trees. The season on sharpies had long passed, and we could only admire them from a distance. As we walked through the timber, I found—for the first time—numerous actual snow roosts where the sharptails had burrowed into the deep snow to survive the harsh elements. When the sharptails flushed, they had made wing marks in the snow on either side of the snow roosts. It made me appreciate the hardiness of our native grouse.

I hiked past the Pinch—an area where the cover in the big draw narrows—and up to the next patch of quakies. I glanced over at the grove, looked away momentarily and turned back to the woods. I then spied a ruffed grouse standing where one had not been only seconds before. Amazingly, the grouse had heard us coming and hopped out of his snow roost while I wasn't looking.

The dogs and I walked toward the grouse, and it flushed hard right to the left up the draw and I shot behind it twice. More times than not, while hunting in the late season, I often feel this desperation—knowing that it will be almost a year before the dogs and I can take to the grouse woods again—and it definitely impacts my shooting.

Despite my poor shooting, the grouse's deep snow roost was interesting to see and study, and I took a few photos. The dogs and I tried to follow up the ruffie, and it flushed off the top of the draw's edge and flew down a hundred yards into the heart of the big draw, offering no shot. With the difficulty of the walking, we did not follow after the beautiful bird but let him live to play another day. This seemed like a good way to end our season.

Truly, hunting in the dead of winter can be an exercise of frustration and—as these stories show—can often take a turn for the worse. However, there are times when the quiet, peace and beauty of the snowy grouse woods make the effort worthwhile. Grouse are undoubtedly a hardy bird to survive such harsh winters. I like to think that my struggles in late-season grouse hunting have made me hardier as well. Such desperate days afield make me appreciate even more the glory days of grouse hunting in September, October and early November.

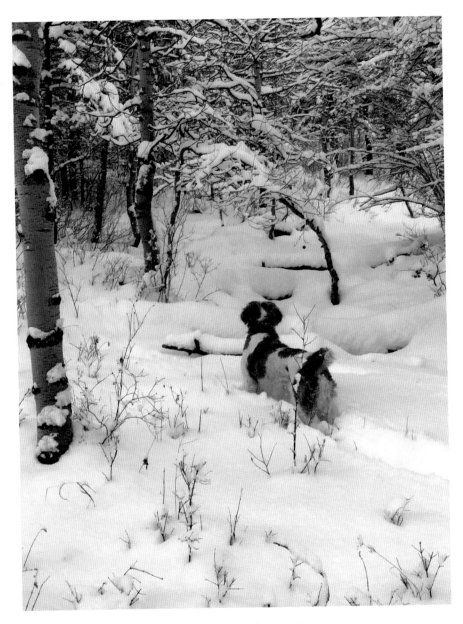

Misty on point in Butt Kickins' in the bare November woods.

Chapter 14
THE COWBOY AND THE HIPPIE GO HUNTING

Now was it just coincidence or some weird act of fate that brought these two together on the road?
—Chris Ledoux, "The Cowboy and the Hippie"

I have a good friend and hunting buddy named Scott Johnson. Two people could not come from more different backgrounds: me, as a teenager, a long-haired, skateboarding, punk-rocking, hippie; him, a skinny, Wrangler- and crap-kicker-wearing rodeo cowboy. Our wives became friends through church, and as a result, Scott and I began to hang out and soon realized that, despite our diverse life experiences, we get along really well.

But we still give each other a hard time about the other's past. He liked country music and heavy metal, the latter of which I despise and call "butt rock" because it stinks, oh, so bad. He, on the other hand, hates the new wave and punk I listened to as a kid and thinks Depeche Mode is the lamest band ever. To each his own! We probably would have fought each other back in high school.

Scott recently became addicted to fly-fishing, and on top of that, he picked up a bird dog this summer, a chocolate Lab named Gunner, so his outdoor affliction is complete. We have already spent quite a few days on the water and afield this year.

One weekend in September 2012, I invited Scott to go hunt one of my favorite hunting spots, a covert I call Grouse Springs. I picked up Scott at his

house at 6:45 a.m., and after getting some fuel and food, we headed east into the boonies. As we drove, Scott related some of his redneck escapades along the very road we traveled. I shared some war stories of my own. We laughed as we both contemplated how clueless we were as kids and how lucky (or *blessed*) we are to still be alive. We have come a long way. Fortunately, we both escaped the follies of our youth.

Upon arrival, we parked at a turnout along the rugged road not far from Grouse Springs, which is an area of sage and bitter brush foothills sloping up to an almost-flat alpine ridge I call Sunrise Ridge. In the contours of the foothills are thick and long strips of quakies, impenetrable at places. Each patch usually holds a few ruffed grouse and sometimes even a blue grouse or two. After letting the dogs out of the back of the station wagon, we hunted up the first stretch of quakies in which I've rarely found birds, and again, it was true to form.

We quickly hiked over the sagebrush bench into the next and biggest draw with springs that act as a grouse magnet, hence the name "Grouse Springs."

The Cowboy, Scott Johnson, with his camouflage duck gun and game vest, traverses the hillside at Grouse Springs.

In the small opening above the springs we saw tons of grouse sign, so we knew they were around. We pushed uphill through the tangle hoping to find some of these elusive birds.

As we struggled, scratched and crawled through the thick stuff, Scott flushed a grouse and quickly harvested it with his semi-auto camouflaged duck gun, a gun fit for a redneck, if ever there was one. I worked over toward Scott. A ruffie flushed right in front of me toward a tree, and I tried to shoot before it landed. The shot with my over and under was directly on, and a halo of feathers *poofed* in full view. In retrospect, I should have let the grouse settle in the tree and then reflushed it for a sportier shot, but in ruffed grouse hunting, you take every opportunity you get.

From the head of Grouse Springs, we worked over the next bench to a draw I call "Grouse Alley," which has always been productive. I took a few pictures of Scott as he walked down the two-track into the alley. Of course, a grouse flushed right at that time. *Dirty bugger!* We hunted down through the alley in hopes of relocating the grouse, but in the thick September foliage, it gave us the slip.

Down by the cattle pond where the dogs could cool off and get a drink, we took a break. Scott offered to share some of his granola with me.

"It's 'vegan approved,'" Scott said sarcastically.

I laughed and responded, "You better watch out. If I eat this stuff, I may get up and hug a tree."

"Have at it, ya hippie!" Scott retorted. We both had a good chuckle.

From Grouse Alley, we climbed over the next bench into a quakie strip I have never checked out in the last eight years of hunting this area. Grouse Springs and Grouse Alley have always been so consistent that I just never took the time to tromp through it. For that reason, I have since named this stretch "the Forgotten Covert."

As soon as we stepped into the timber, the dogs flushed a grouse. We pursued, and the dogs reflushed it into a tree. I yelled at the grouse to make it fly, and it gave us a good quartering away shot. Scott was in a better position than me, and I watched him promptly drop the grouse.

"Nice shot!" I praised enthusiastically.

Gunner made another nice retrieve, and the Cowboy had two birds in the bag.

Once we made it to the top of the Forgotten Covert, Scott noticed his sunglasses were missing. The gnarliness of the cover had pulled the glasses right from his face without him even knowing it. This is not the first lost personal valuable in this hunting locale.

Idaho Ruffed Grouse Hunting

Scott thought that maybe his glasses came off down in Grouse Alley where we had rested because that is where he had taken off his long-sleeve shirt in the heat. So we hiked back across the bench over to the head of Grouse Alley toward a stretch of trees that we had not yet hunted.

As we walked, Scott said, "I'm going to start calling you 'Hip' because of the 'Blue Grouse Hippie' sticker on your car.'"

He then told me about a funny song by Chris Ledoux named "The Cowboy and the Hippie," which tells of a wandering cowboy and hippie who meet up in difficult circumstances and—to put it lightly—start off with a strained relationship. He related the following lyrics: "Some folks don't realize that it's a well-known fact cowboys and hippies ain't never got along." With a chuckle, Scott related that the Cowboy said of the Hippie's strong aroma:

Well man that really did it he couldn't take no more.
And he tied his old bandana around his face.
He said you greasy stinking hippie you'd put a skunk to shame.
Boy you're a disgrace to the human race.
And the Hippie replied: Man you don't smell so sweet yourself
Well I'm not too sure what that green stuff is on your boots and on your jeans
But whew, it's enough to make a buzzard belch.

We laughed as Scott related that they avoided a fight, made their peace and both went on their stinky ways, the hippie going east and the cowboy west. True to the song, we both were getting a little ripe from the day's heat and the exertion of the hike. So the song seemed to compliment the day and the experience perfectly.

As we hunted down the strip of quakies, we found no birds until we reached the two-track that cuts down through the trees of Grouse Alley. We followed the sound of the flush, and as we approached, the bird landed in a tree beside me. I clawed through the bramble and it flushed again, giving me a good opportunity, but I held off because I did not want to repeat the previous close shot on my first bird. The bird headed to another tree limb, and I marked it down perfectly. The Cowboy and I then took turns pitching sticks to try and get the bird to flush again for a shot. We actually hit the bird twice, but it would not move.

Determined, I then went over to the tree in which the bird sat and—making good on my promise to *hug* a tree—gave it a good shake with both

hands. That was the last straw for the grouse, and it flushed, presenting Scott with a prime opportunity, on which he capitalized.

"Good shot!" I congratulated. "Now that's what I call teamwork!"

Again, Gunner made a nice retrieve, and that made three birds bagged by the Cowboy and one by the Hippie.

"This is the best day of hunting I've had in a long time," Scott said with a smile.

"You shot awesome!" I complimented. "It has been a fun day."

And it had been an excellent hunt. Even though the Cowboy took most of the shots, I felt like we had worked together to harvest each of those birds. So, in my mind, the day was a tremendous success for all.

I guess, despite their differences (and their smells), cowboys and hippies can get along.

Chapter 15

THE OUTHOUSE COVERT

It's a short trip from the penthouse to the outhouse.
—Paul Dietzel

Finding and naming coverts has to be one of the most fun things about upland game hunting. And the name can't just be any name; it has to be specific to that spot, and it has to mean something. Some of my favorite coverts have names like Grouseketeer Ridge, the Royal Macnab, the Miracle Half Mile, Hope's Hill, Grouse Springs, Grouse Rock, the Blazing Saddle, the Trail to Quail and the Big Uneasy. I have written about these special coverts numerous times. Their names evoke so many memories that I cannot say them or walk through them without thinking of countless experiences that only grow sweeter through the years.

On Thursday, September 6, 2012, I tried a new covert that I had never hunted before. The birds that day were plenteous, but unfortunately, my shooting was just plain pitiful. Keep in mind that before I found this covert, I had already missed a ruffed grouse and a blue that day. Here is the account from my journal about my first experience in this new covert:

> *I had one more place I wanted to try right on the right-hand side of the road as we headed towards home. On an earlier hunt this year in this same area, I noticed a small creek descending down a narrow draw, filled with quaking aspens. I thought to myself:* I need to try that sometime.

The Heartbeat of the Woods

After parking, Misty and I worked up the two track and the cover looked okay, but not prime. Misty hunted quite a bit ahead of me and surprisingly flushed a blue right over my head, which I missed twice. I never make that shot.

She then went into this sage flat on the right-hand side of the road and blues started buzzing out in all directions. I snap-shot at one, but was not in the best position and missed. I wanted to go a little further up the trail in hopes of finding more coveys, but it was getting dark quickly and I knew we would relocate a few birds on the way back down as they all flushed in that direction.

Sure enough, Misty ran up on the hillside near the two-track road and pointed. Again, a blue flushed right over my head and I missed him twice and watched him fly into a tall pine tree. Misty moved a little ways downhill and again pointed, presenting me with the exact same shots I had just missed with the exact same results. In my frustration, I even futilely tried to pull the trigger a third time, but I only had two barrels and two shots. So, all said, I missed nine times that day. That's pathetic! I just had to laugh as it was a fun hunt and we had plenty of action. I'm thinking of naming the covert "The Hive."

While I kicked around this name for a few days, it just didn't seem to fit. Sure, the blues buzzed around me like bees and my poor shooting sure stung, but this name just would not do. Something was missing.

The following Thursday, one week after this first experience, my brother Jake and I decided to try our luck at this new covert. I recorded the following in my journal:

From Grouseketeer Ridge, we headed down to the new covert, which I was going to call "The Hive," but it now has a new name. We hiked further up the draw than I had the first time and observed, to our surprise, an outhouse in the middle of nowhere. What a weird place to put an outhouse! I took a few pictures of Jake approaching the outhouse, pointing to it and smiling. At that point, I realized that this covert is now officially "The Outhouse Covert," because (1) it inexplicably contains an outhouse; and (2) my shooting was Pure-T Crap the first time I went there. The name seems just perfect!

Jake and I did not find the blues as before, but we hiked up to where the draw opened up, and the scenery was truly beautiful as we observed

Above: Jacob Wayment hikes near the Outhouse in the middle of nowhere on the day the covert got its name.

Left: Brother Shawn poses with a big smile and a nice ruffed grouse we found near the Outhouse.

castle-like rock formations and forests starting to take on their colorful fall foliage.

On the way back, Misty flushed some ruffed grouse in the thick trees off to the side of the two-track, one of which I located in the tree. Jake couldn't see it, but I told him while pointing with my barrel, "Jake, it's right there!"

After a second, Jake finally saw the ruffie and walked toward it. It flushed straightaway, and Jake missed it on his first shot but hit it on his second. Backing Jake up, I shot right after his second shot and thumped it again. I felt bad for shooting Jake's bird and thought I should have had more faith in my little brother's shooting abilities, but Jake was gracious about my mistake.

After taking a few pictures of Jake with his bird, we walked under a branch hanging over the road, and another grouse flushed above us. Jake promptly missed it. So I was not the only one whose shooting left a little to be desired in this new covert. Notwithstanding, we were in good spirits because of the night's successes.

So the Outhouse Covert kind of just named itself. No other name would do it justice. Hopefully, in the future, my shooting in this fun little canyon will rise above its crappy beginnings.

Chapter 16
CONVERSATION WITH GEORGE

There are men who hunt grouse, and there are grouse hunters.
—George King, That's Ruff!

On October 25, 2012, I wrote the following review of one of my favorite books, George King's *That's Ruff!: Reflections from Grouse Country*, on the Upland Ways blog:

Since I started bird hunting over fourteen years ago, I have naturally gravitated towards grouse—any kind of grouse. In Idaho we have five species, ruffed, dusky (aka "blue"), sharp-tailed, sage, and spruce grouse. I love every one of them. I love everything about grouse: Their environs, their beauty, their thunderous flushes, and the thrill of taking one on the wing over my Brittanys. They are the essence of wild. *While I pursue and enjoy other game birds, I am first and foremost a grouse hunter and forest grouse (i.e. ruffies and blues) are my favorite.*

Over the years, I have collected and read many books on ruffed grouse hunting. Some were great and some were so-so. My favorite bird hunting author is none other than the Poet Laureate of ruffed grouse hunting himself, Burton L. Spiller. Very few other writers capture those special little details, experiences, thoughts, and feelings of a grouse hunter like Spiller.

I just read for the second time, That's Ruff!: Reflections from Grouse Country, *by George King. The first time I read this book I absolutely* loved *it. In fact, I felt it was so good that I have wanted to do*

The Heartbeat of the Woods

a book review ever since, but I was just not sure if I could do it justice. So I drug my feet.

Upon the second reading, I decided it was time to say my peace about That's Ruff! *In my humble opinion, George King is the best writer on ruffed grouse hunting since Burton L. Spiller, and I mean to take nothing away from great writers like Tom Huggler, George Bird Evans, Tom Davis, Ted Nelson Lundrigan, Robert F. Jones, Steve Mulak, or Bill Tapply, etc. whose writings I've thoroughly enjoyed. However, since Spiller, no one has fully captured the essence of the grouse hunter—or "Brush Worns" as King calls them—and the experience of grouse hunting, as well as George King. Like Spiller's work, this book embodies a lifelong love affair with ruffed grouse and grouse hunting. At times, this extremely well written book is sentimental, funny, serious, sad, but never sappy. Time and again as I read through King's stories, I was struck by how similar his experiences and thoughts were to my own. King accurately captures so many aspects of the hunt that anyone who has pursued the noble ruffed grouse can't help but relate.*

To give you a little taste of King's humorous side, I wanted to share the following limerick:

A hunter whose name was Joe Tallerschmidt,
Studied grouse with a great deal of scholarship,
He learned that the name,
Of this frustrating game,
Is to shoot when you can and then hollerschidt.

King's poems and stories alone are worth the price of admission, but the book also lets you peer into the past to learn more about other great outdoor writers including Tap Tapply, Frank Woolner, and Burton Spiller himself. King knew and communicated with these iconic men. In fact, King was instrumental in the reprinting of Spiller's classic books, Grouse Feathers *and* More Grouse Feathers. *But for King's efforts, these books would not be readily available to our generation of grouse hunters. I found it very enjoyable to get to know these great men a little better through their letters and King's recollections. Amazingly, as King relates, Burton Spiller was so unassuming that he believed he was a nonentity and he really had no idea of the impact he has had on those who read and treasure his books.*

One of the things that I like best about King as a person is that he is equally as humble as Spiller. I was impressed to learn that King was the founder of the Grouse Cover *newsletter which he started in 1969 and*

continued until 1973, when he had to quit because of a personal illness. In That's Ruff!, we learn about this newsletter and how it spread like wildfire to obsessed ruffed grouse hunters who were hungry for anything grouse and grouse hunting they could get their hands on. As you read the excerpts from this newsletter, you can see how it easily filled the void. This newsletter brought together grouse hunters from all over the country and allowed them to share in their unique identity and to commiserate in their incurable addiction.

In fact, the subscribers requested that King create an organization of which they could all be a part. Pursuant to this request, King created the Ancient and Honorable Order of Brush Worn Partridge Hunters (or "Brush Worns" for short) and when a person subscribed to Grouse Cover, *they were issued a certificate and could also order a patch showing they were officially a Brush Worn. To my understanding, after almost 40 years, Brush Worns still exhibit their certificates and patches with pride. I want some of those for myself!*

I really enjoyed the portions of the letters from the Brush Worns that King shares in the book. To give you a taste of these characters, here are a few gems from one fellow Brush Worn, Ray Bane:

On Ray's shooting ability: "If you gave me a full box of shells, and hung up 25 grouse on a clothes-line, I'd still miss a couple of them."

On Ray's ambitions: "All I want from life is one more shot at a grouse."

On how much Ray Bane loved to hunt: "I'd crawl right over a naked lady to go grouse hunting."

Does that sound like any birdbrains that you know? Shoot, I want to be part of such a great group. So many years later and I already feel as if I belong. And this group of crazy Brush Worns came together because of the efforts of King. Yet King never brags or seeks attention or personal praise for this accomplishment.

In closing, I want to share a few quotes from the chapter, "The Grouse Hunter's Heritage," which capture the essence of this book and our great sport. On the ruffed grouse, King wrote:

The grouse, to the grouse hunter, is the very spirit of all the things around him—the breath of life in rocks and trees and fallen leaves, in fragrant bogs and mossy logs and mountain tops. I don't know if the Lord made the grouse to fit the cover, or the cover to fit the grouse, but whichever it was, He must surely consider the result to be among His finest work.

The Heartbeat of the Woods

On grouse coverts in his beloved Appalachian Mountains, King eloquently stated:

On the top of a mountain, the air is fresher, the sky is bluer, the wind is stronger, a man is taller, and sunsets last longer than anywhere else on earth. I hope I don't find out someday that heaven isn't "up," for if that's the case, I've spent a lot of time on mountains thinking it was closer than it was.

On grouse dogs, King declared:

It seems to me that any man who loves the grouse would have to love a dog, for these are two of his Maker's finest creations. And though they are our favorites, they please us in exactly opposite ways: one the very essence of all things wild and free—the other the embodiment of loyalty and service. And now, in those brief few moments of the point, they are linked by a tenuous thread of scent, and primal instincts that neither of them can fully understand.

Amen. What more can I say? George King has truly been there and has captured so succinctly the bird, the covers, the dogs and the sport we so intensely love.

So here is my final verdict on That's Ruff!*:* Mark my words, this book is a sporting classic and will go down in history as one of the greatest upland bird hunting books ever written!

Thanks for finishing this lifelong project, George.

I didn't think much more about the review after I posted it; I had said my peace. However, on Saturday morning, December 1, 2012, as I was barbecuing some ribs on my smoker grill in the cold and snow, I received the following e-mail:

Dear Mr. Wayment,

I just found your wonderful review of my book and would like to say thank you in person. Hope this reaches you. Please email or call me.

Best regards,

George King

Below the name was a phone number. I was amazed and humbled by this e-mail. Of course, I was delighted to know that Mr. King had read and enjoyed my review, but I did not expect him to reach out to me. I typically am the type to shy away from famous people, but for some reason, I thought, *What the heck, I'll give him a call!*

Only seconds later, George answered the phone, and I tentatively asked, "Is George there?"

He replied, "This is George."

"Hello, this is Andy Wayment."

He instantly thanked me profusely for the book review. I replied that it was my pleasure and that I meant every single word. I told him that I was thinking earlier that very morning what a shame it would have been if he hadn't finished the book (which he admitted he almost did not) and wondered how many other hunters out there experience all of this excitement and beauty but then take it to their graves without sharing it with others. I thanked him for finishing the book and told him that, in my opinion, it is the best work on grouse hunting since Burton Spiller. He felt honored by the compliment.

We talked about Burton Spiller and how neat it was that George got to meet him shortly before he passed away. George told me that in addition to being a writer, Burt was also the grower of award-winning gladioli, which I had previously read about Spiller. I expressed that Spiller is my favorite because he was not only a good writer but also a good man and that I aspire to write like him. I thanked George for his efforts in bringing back Spiller's works and told him that I realized that if it wasn't for his efforts, the classic Spiller works would not be so readily available to my generation of sportsmen.

George asked me how I can be a practicing attorney and still find time to write for the Upland Ways and Upland Equations blogs. I replied that I have six kids, so that further limits my time. I explained how writing about my hunting and fishing adventures is very therapeutic for the stress that I endure as an attorney and that writing is a significant part of who I am.

George told me about retiring early and enjoying his farm and grouse hunting. He then expressed his philosophy about enjoying oneself before it's too late. As far as I can recollect, George's exact words were: "Quit as soon as you can while your health is still good. I have people ask me all the time if I wished I would have worked longer before retiring so that I would have had a bigger pension. I tell them, 'Heck no!' How can I put a price on all of the time I've spent doing what I love? You can't measure that."

The Heartbeat of the Woods

George's words reminded me of some things a few of my favorite writers had written. Havilah Babcock's motto was to "Work hard and quit suddenly." Likewise, the great Idahoan Ted Trueblood wrote of pursuing his outdoor passion: "Don't wait too long. If you wait until tomorrow, tomorrow may never come." Lastly, an acquaintance of Burton Spiller actually took him to task on his constant sporting endeavors and asked, "Did you ever count the cost of your hunting?...Of the time you have lost and the money you spent?" This question sparked the timeless response by the poet laureate of grouse hunting:

> *I replied and truthfully too, that I never lost a moment's time in hunting: that I counted only that time lost which I spent working....You think the days and weeks I have spent afield were wasted. Well, let me tell you this. If such a thing were possible, I would not trade even the memories of those glorious days for all the money you will ever possess.*

Now we can add George King to this list of wise sages.

George mentioned specifically, "I am so glad that you shared parts of 'The Grouse Hunter's Heritage.' For me, this is one of the best parts of my book."

I responded to him, "I totally agree. You perfectly summed up in that chapter so many things Brush Worns have experienced and felt about their beloved sport, favorite gamebird and the beautiful places they inhabit."

One of the most thrilling parts of our telephone conversation came toward the end. In my review, I wishfully proclaimed a desire to be a member of the Ancient and Honorable Order of Brush Worn Partridge Hunters: "So many years later and I already feel as if I belong." As we were wrapping up our conversation, George said something I will always treasure: "Before we hang up, I don't want to forget that there is something important that I wanted to tell you. You are the exact sort of guy I had in mind when I created the Brush Worns. In gratitude of your wonderful review of my book, I am hereby dubbing you an honorary Brush Worn."

I heartily responded, "This is truly an honor. Thank you so much!"

He later mailed me a signed Brush Worn certificate, which is one of my prized possessions. Interestingly, he randomly input a date of November 30, 1998, on the certificate, which was during the very year and hunting season that I began hunting ruffed grouse and took my first ruffie on the wing during law school.

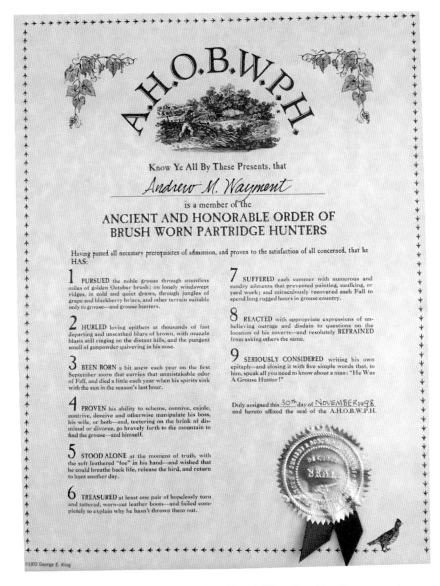

The author's Ancient and Honorable Order of Brush Worn Partridge Hunters certificate given to him by George King after their conversation.

For me, visiting with George was very enjoyable. I was amazed by his humility, his likeability and his generosity. I felt truly honored to be inducted into the ranks of the Brush Worns. Talking with George was like tapping into our great grouse hunting and writing heritage, if only for a moment.

The Heartbeat of the Woods

As I said in my review of *That's Ruff!*, this book is a true classic and will go down in history as one of the greatest upland bird hunting books ever written. After talking with George on the phone, I can attest to all you diehard ruffed grouse hunters that George is the real deal. Like Spiller, George is not only a great writer but also a good man. Thank you for everything, George.

On September 13, 2013, less than a year after he and I had our conversation and after I wrote this chapter, George E. King passed away. Many Brush Worns, including myself, were very saddened by this loss. There is so much more I would have loved to discuss with him.

Chapter 17

TWENTY THINGS EVERY BRUSH WORN SHOULD KNOW ABOUT OL' RUFF

Other boys of my acquaintance might content themselves with slaying elephants and lions and other inconsequential members of the animal kingdom, but I wanted none of that in mine. Northing but the lordly pa'tridge would satisfy me.
—Burton L. Spiller, "His Majesty, the Grouse"

This chapter is dedicated to the memory of George E. King, the author of *That's Ruff!*, one of the finest books ever written on the pursuit of the ruffed grouse. George founded the newsletter *Grouse Cover* and the Ancient and Honorable Order of the Brush Worn Partridge Hunters, or "Brush Worns" for short, and brought grouse hunters from all walks of life together as few have ever done. George left a grand legacy for all grouse hunters, and he will be missed.

1. When I hear the phrase "from sea to shining sea," I think of the ruffed grouse, or Ol' Ruff, because he can be found from East Coast to West, even up to Alaska. Wherever he is found, Ol' Ruff is a grand game bird.
2. Every single ruffed grouse, whether gray, brown, red or intermediate phased, is a masterpiece of art from the palette of the Creator. All ruffs are beautiful, but a red-phased bird is a rare trophy to be celebrated, especially in the West.
3. Ol' Ruff is a trickster. Using his fan tail like a rudder, he can juke and jive like no other grouse and can magically put obstacles such as trees or rocks in your way quicker than any other game bird. We don't call him "the trickiest thing in feathers" for nothing!

4. Ruffed grouse inhabit the gnarliest places that few men see, cover so thick that you might just get twigged in the eye, scratched on all exposed skin or, as Grampa Grouse put it, "horse collared." Most people shy away from such places, but not Brush Worns, because they know this is where Ol' Ruff dwells.

5. There is no finer table fare than the ruffed grouse. Get creative! Think fajitas, Tandoori or Makhani grouse. You can't go wrong with the delicate meat of the ruffed grouse unless you overcook it!

6. Ol' Ruff has inspired the very best in sporting literature from Burton Spiller, the poet laureate of grouse hunting, to George King; George Bird Evans; Grampa Grouse; Corey Ford; Bill Tapply; Tom Davis; Tom Huggler; Ted Nelson Lundrigan; Steve Mulak; Robert F. Jones; William Harnden Foster; and many others. Reading their books is almost as good as pursuing Ol' Ruff himself, but not quite.

7. The ruffed grouse is known by many names—Ol' Ruff, ruff, ruffie, partridge, pa'tridge, fool hen, pine hen, willow grouse, the king—but no matter the name, he is a prince of a game bird and well loved by all who know him well.

8. Every successful shot at a ruffed grouse is a lucky shot, and Brush Worns are truly surprised at every single one that falls. No bird can bring on a shooting slump quite like Ol' Ruff. Remember shooting is instinctual, especially for ruffed grouse. Don't think about it so much and just keep swinging, and under Tap Tapply's law of averages, you'll start hitting again.

9. To be successful at hunting Ol' Ruff, you've got to learn to snap shoot. William Harnden Foster invented skeet shooting to practice shooting for grouse hunting, but there is nothing that can replicate the thunder of a grouse flush, the resulting adrenalin that pumps through your veins or the difficult shots in tight cover. In my humble opinion, snap-shooting can only be learned through real-time experience.

10. Ruffies are a bird of the second-growth forest. They need young, diverse forests to thrive. Old growth is no good for Ol' Ruff (or most other wildlife, for that matter). Logging, fires and well-managed cattle grazing can work wonders for grouse habitat and grouse and create the tangles they need to survive.

11. Ol' Ruff is a noble game bird, and he deserves respect. Brush Worns understand that to take one on the wing is the only sporting way.

12. A Brush Worn never forgets his first ruffed grouse taken on the wing. It's at that moment that he changes from a meat hunter to a sportsman. Welcome to the fold, Brother Brush Worn!

13. The drumming of a ruffed grouse in the spring, like a Tom turkey's gobble, is a herald of good things to come. The noise carries a long way and is deceiving as to where it originates. A drumming grouse can be ten feet away or a hundred yards; it's often hard to tell.

14. The places Ol' Ruff lives and the experiences had therein inspire names that flow so naturally, like Grouse Springs, Grouse Alley, the Pinch, the Outhouse Covert, Grouse Rock, the Blazing Saddle, the Forgotten Covert, Center Stage, Dusty's Nub or Hearth and Home.

15. The pursuit of ruffed grouse with a pair of good dogs is the very height of hunting. When you load up the car and the dogs overhear the jingle of their bell, they'll get as excited as you about the upcoming grouse hunt. The teamwork necessary to successfully take a ruffed grouse will forge an unbreakable bond between the hunter and his dogs.

16. Some have written that the western ruffed grouse is a subpar bird, the quintessential fool hen, but despite this slander, Ol' Ruff is a quick learner, and though he can be naïve at first, after a few encounters with dogs and bird hunters, he will be as wily and challenging as any other game bird, maybe even more so.

Misty points a ruffed grouse at a sweet spot on the trail to the Outhouse.

Stonewall Brittany by Peter Corbin. *www.petercorbin.com*.

A beautiful red-phased fan of a hen ruffed grouse.

Doubled Down by Ross B. Young. *www.rossyoung.com.*

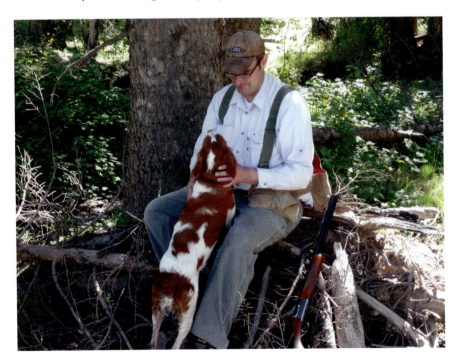

Andy and his American Brittany, Misty, take a break from hunting.

Old Gates Ruffs by Ross B. Young. *www.rossyoung.com*.

Grouse with Apples by Bob White. *www.bobwhitestudio.com*.

The Royal Macnab, a favorite covert, is such a heavenly place in October.

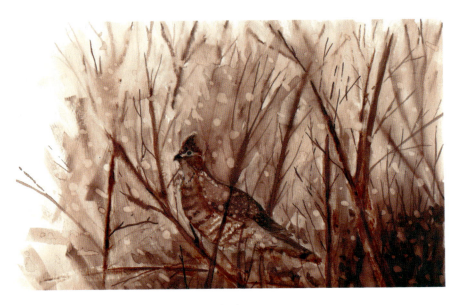

Red-phased Ruff by M.R. Thompson. *www.uplandart.com.*

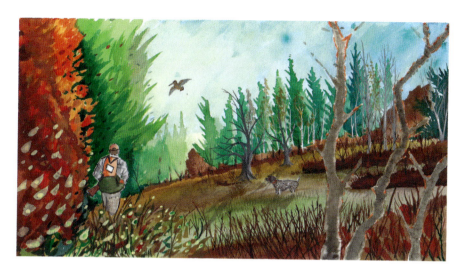

Autumn Walk by M.R. Thompson. *www.uplandart.com*.

Matt Lucia hunts a covert in southeastern Idaho we call the "Blue Grouse Bottleneck."

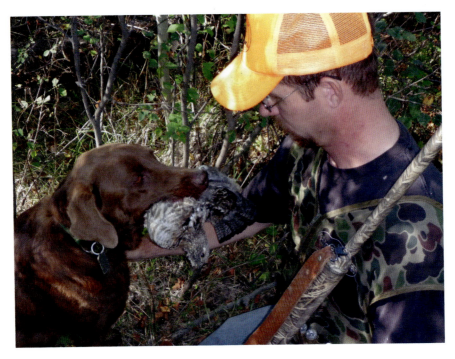

Chocolate Lab Gunner retrieves a grouse for the Cowboy.

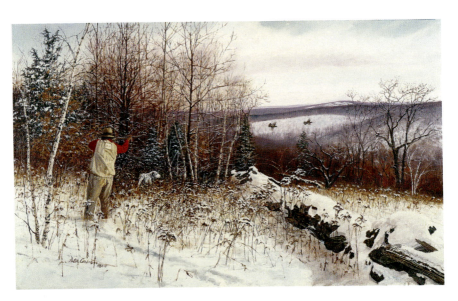

Chance to Double by Peter Corbin. *www.petercorbin.com.*

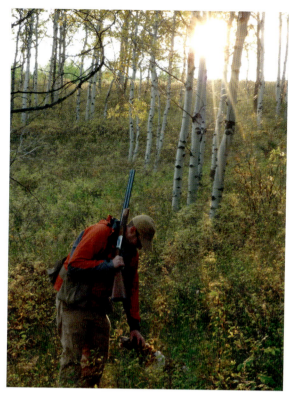

Left: Andy pets Misty at first light in a golden grove of October quakies.

Below: *Silent Bells* by Ross B. Young. *www.rossyoung.com*.

A late-season grouse from Grouse Rock.

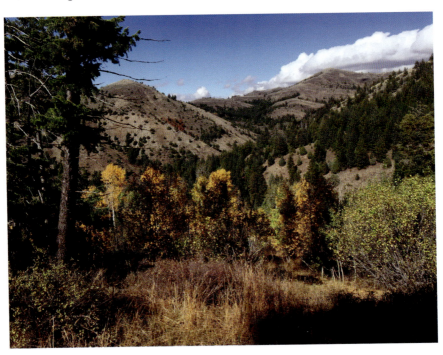

This picture typifies grouse cover in southeastern Idaho.

This two-track on the Royal Macnab leads to some excellent grouse cover.

The dog work and shot weren't too pretty, but this beautiful red-phased grouse sure made up for it.

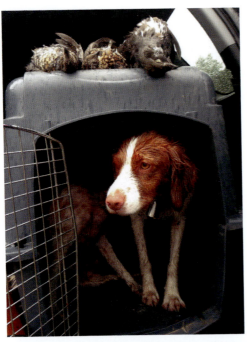

Left: Soggy dogs.

Below: Soggy grouse.

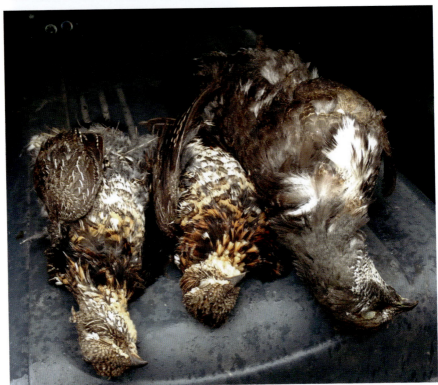

Left: Brother Shawn approaches with a grouse in hand.

Below: Misty after an eye-opening hunt in the Beaver Meadows.

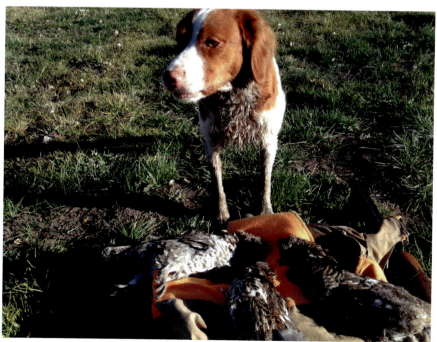

Above: The stunning grouse where it fell made for a beautiful picture.

Below: Blow Down Grouse by Ross B. Young. *www.rossyoung.com.*

The king of the uplands with a classic American double, the Ithaca NID.

It's therapeutic to stop and take in the beauty while grouse hunting.

Misty was a bona fide grouse dog.

Ink Grouse by M.R. Thompson. *www.uplandart.com*.

The Road Home by Bob White. *www.bobwhitestudio.com.*

Chance for a Double-Ruffed Grouse by Eldridge Hardie. *www.eldridgehardie.com.*

Andy, Sunny and Misty with a sharptailed grouse from the Royal Macnab.

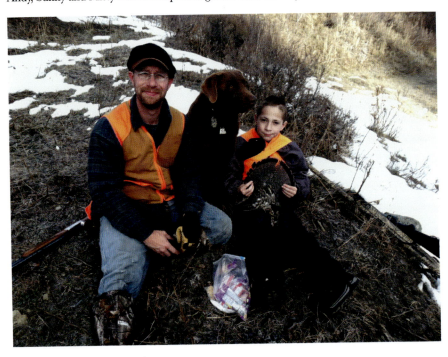

Scott Johnson, Gunner and Cole take a snack break during our Thanksgiving morning hunt.

17. Brush Worns are an odd, reclusive lot and are very protective of their secret coverts. Despite their hard shell, with the common love of Ol' Ruff and the places he dwells, Brush Worns, when they break through that crusty barrier, often find instant camaraderie with each other, the likes of which is not found in most other endeavors.

18. Ol' Ruff can be a cyclical bird, and some years there are more than others. The years of scarcity sure make a Brush Worn appreciate the years of plenty, but the pendulum always seems to swing back, and if the habitat remains, the numbers will return. Be sure to not overshoot your coverts and make sure and leave some seed birds.

19. Keep a journal of your pursuit of Ol' Ruff and you will enjoy your hunts for years to come.

20. Above all, remember that no day in the grouse woods with your bird dog is wasted. Life is fleeting, and every single day afield in pursuit of Ol' Ruff is a blessing to be savored. Soak it up because the hunting season only comes around once a year.

Chapter 18

GLORY DAYS

But of all the crazy hunters that we know...none breathes autumn more deeply than [a grouse hunter], And none makes finer use of bright October.
—*John Madson,* Ruffed Grouse

As the long cold set in during the winter of 2013–14 and the hunting seasons on all of Idaho's upland game species came to a close, I sat beside the fire and reflected on days afield with my bird dogs, friends and brother Shawn. Reviewing my journal entries, I noticed that, undoubtedly, bird numbers were down in 2013 in Idaho, and as a result, we saw and took fewer birds. However, the scarcity of birds did not detract one bit from the hunting season's charm. Rather, each bird flushed, shot and retrieved, or missed altogether, was savored that much more. We had been blessed.

One journal entry from the beginning of the season regarding a forest grouse hunt with a good friend, Matt Tower, really warmed my soul this frigid time of year:

Saturday, September 7, 2013

I picked up Matt at 7:00 a.m. for our hunt. It was hard to leave Sunny Girl behind, but I didn't feel I could take her because she fainted last week during a hunt. Matt and I first hunted Grouseketeer Ridge and in the dark timber Misty bumped a number of blues. One flushed across the road,

which Matt and I both missed. Another one got up and Matt thumped it. Misty located the big blue in some downed timber, but did not make a full retrieve. All said we moved 5 or 6 blues on Grouseketeer Ridge. I wish Misty was a better pointer, that little bird bumpin' turd!

On the backside of the ridge near Dusty's Nub, Misty located a ruffie in a thick quakie patch below the road. I should have paid more attention to her because I knew she was birdy, but because of her earlier bird bustin' ways, when a bird did not readily get up, I figured she was dinking around. Of course, a ruffed grouse got up and flew into a nearby tree. Matt and I tried to get into position for the reflush and the crafty grouse presented only a brief shot, which I didn't take because I hesitated. We could not relocate the bird thereafter. In my defense, I should mention that we have never seen any birds in that particular patch. I should have trusted my dog!

We didn't find any more grouse on Grouseketeer Ridge that morning, so we headed down to the Outhouse Covert for one final hunt:

Matt and I hiked way up to the old Outhouse, past the big guzzler where Sunny passed out the week before. Along the way Misty bumped a few birds on the right-hand hillside, but we never saw or relocated any of them.

We pushed all the way up to the top of the draw and Misty flushed a grouse. I shot trying to catch the bird before it lit into a tree. The shot felt good, but I missed low because the bird then changed course and began flying down the draw directly toward me. I instinctively shot and dropped it. I was totally surprised because I never make that shot.

Matt, who was behind me said, "I watched that whole thing go down and that was awesome!"

It was a gargantuan blue grouse. I responded excitedly, "It's amazing how a bird in the bag brightens the spirits!"

We decided to turn around and head back down the draw. Matt opted to hunt the forested hillside to see if he could get up some more birds. This was the ticket. Within five minutes, Matt flushed a ruffed grouse and brought it down with two shots.

He yelled down to me, "Andy, there's more birds up here. I can hear the rest of the covey chirping."

I then began the arduous climb up the hill to get into position. One flushed as I approached, but I never saw it in the thick tangle. When I got to within twenty yards of Matt, he stated, "I see the bird, but I can't get to it in this thick stuff."

Misty points a ruffed grouse along the trail below Dusty's Nub.

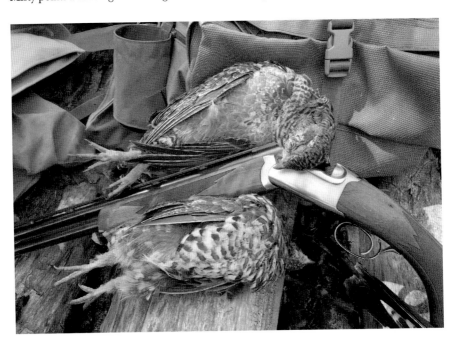

A blue, a ruff and a Ruger Red Label.

So we decided to put Misty's bird bustin' to good use and sent her into the thicket.

Matt, who had a good view, exclaimed, "Misty's onto that bird now, get ready, here it comes!"

The bird then ripped straight up through the canopy and I missed it on the first shot, but as it leveled off and flew uphill, it gave me a perfect straightaway, which I made good on. Misty located the downed bird and retrieved it to hand. It was a red-phased juvenile ruffed grouse. Simply beautiful! The day had suddenly turned into one of my best days of hunting so far this year. It's funny how that happens.

By no means was this a "perfect" hunt, but they never are (at least for me). However, the beauty of the scenery, the thrill of the flushes, the exultation of good shots made and the camaraderie of a good friend more than made up for any imperfections. Every bird hunter has a cache of days like this stored in his memory that he draws upon on cold winter days. I call them "glory days." No doubt, they carry us through to the next season.

Chapter 19
WHO IS THE BEST WRITER ON GROUSE HUNTING?

> [Grouse hunters'] *attitude is one of unabashed sentimentality (rife among many upland gunners anyway), and it would be pleasant to be one of their cult.*
> —Charles F. Waterman, Hunting Upland Birds

In October 2013, Shawn and I had the opportunity to spend a week bird hunting in the uplands of Idaho with author Tom Davis. Davis wrote an article about this hunt that was published in the October 2014 issue of *Field & Stream* titled "The Great American Bird Hunt." If you don't know, Tom Davis is one of the finest living writers on upland bird hunting. He regularly writes for *The Pointing Dog Journal, Pheasants Forever, Sporting Classics* and *The Shooting Sportsman*. While the bird hunting left much to be desired, we enjoyed hunting with Tom and getting to know him a little better.

On the second day of our hunt, we took Tom to a covert in southern Idaho I call "Grouse Rock," which is one of my favorite ruffed and blue grouse coverts, named after a geologic rock formation near the road that makes the location readily identifiable. However, unlike years past, the grouse were tough to find. The drought had hit the birds hard in Idaho that year. Tom and I hunted one quakie-filled draw in the steep mountains where the golden leaves radiated like a leprechaun's pot of gold. It was simply breathtaking.

Since the hunting was slow, as a lover of outdoor literature, I asked Tom about some of his work that I had read, which was fun for this hunting-book nerd. Specifically, we talked about an article he wrote in *The Pointing*

Author Tom Davis gets his English setter, Tina, ready for the hunt.

Dog Journal about some of his favorite bird-hunting books. I told him that I agreed that Steve Groom's *Pheasant Hunter's Harvest* is the finest book out there on pheasant hunting. He then reiterated that he felt this book was unjustly overshadowed by an inferior book on pheasant hunting (which shall not be named) that came out around the same time as Groom's book. Tom's article inspired me to read Groom's book, and I've agreed with Tom's statement ever since.

Since we were in the grouse woods, I had to ask Tom the question, "Whose writing do you prefer, Burton Spiller or George Bird Evans?" Tom quickly replied, "Burton Spiller, but in my opinion, the best writer on ruffed grouse hunting was William Harnden Foster."

Tom's answer caught me a little off guard because I am a dyed-in-the-wool Burton Spiller fan and feel that he truly deserves the title the "poet laureate of ruffed grouse hunting." Spiller's timeless works speak to me because—first and foremost—Spiller was a good man who happened to love to hunt ruffed grouse and had a knack for telling a great story. I would have loved to spend a day in the grouse woods with Burton Spiller, which is not something

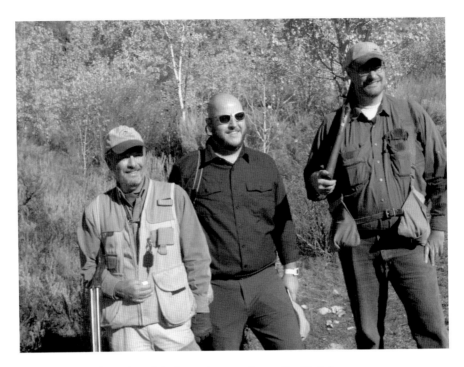

Tom Davis, John Loomis and Andy coming out of a quakie-filled draw.

I can say about every author I have read. Second to Spiller, I would place the late and great George King, the author of *That's Ruff!*, who I had the pleasure of speaking with on the phone and corresponding with by e-mail.

As for Tom's answer, I own a copy and had read William Harnden Foster's book *New England Grouse Shooting* and considered it a truly exceptional where-to/how-to book (which, admittedly, is not my favorite genre), but I would not have placed Foster at the top of my list. I prefer a good story over instructional writing any day.

Regarding his response, Tom went on to say, "Everything that Foster wrote was spot on and is still true to this day." For the most part, I had to agree with Tom on that point, although I stated, with a smile, as we watched my Brittany Misty hunt for grouse in the thick timber, that "Foster did not have anything good to say about my breed of choice."

Tom replied, "True, but at the time pointers and setters were the top grouse dogs and little was known about the continental breeds."

Anyway, it was an interesting conversation about great authors while hunting with a truly great writer of our time. Of course, this is such a

subjective topic because different people like different things depending on their life experience. I can say, however, that from this conversation I gained a greater appreciation for William Harnden Foster and his book.

Tom Davis later went on to write an article in the January–February 2014 issue of *The Pointing Dog Journal* titled "Book Learnin,'" in which he mentions our conversation.

Chapter 20

THE BLAZING SADDLE

[Autumn is] *the very height of creation—it is the reason to everything, it's Nature's ambition. What in summer can equal their gold and greys, their maroons and oranges? Autumn, with its rich memory of all that has gone before,—it's the very height.*
—Corey Ford, The Trickiest Thing in Feathers

Do you have any coverts that you dream about during the off-season when it's freezing cold outside? I have many, but lately, I've been thinking about a special place in some mountains in southern Idaho that I named "the Blazing Saddle."

I first began grouse hunting in the general area in 2001, when some family members and I miraculously discovered a covert we now call "Grouse Rock." I wrote an article about this very experience titled "Roadside Revelations," which appeared in the Autumn 2010 issue of *The Upland Almanac*. Incidentally, this story is now the title chapter to another forthcoming book of mine on bird hunting. For the first few years we hunted it, Grouse Rock was so good we had no need to search elsewhere for birds.

However, in 2004, my dogs, Sunny and Dusty, and I found very few birds when we hunted the wooded draws and fingers of Grouse Rock. So we started to explore the steep hills and draws across the narrow valley from Grouse Rock. One day in November, after hiking up an extremely steep grade, the dogs and I fortuitously stumbled upon a shallow saddle packed tightly with quakies, berry bushes and a few interspersed Douglas fir trees.

The Heartbeat of the Woods

The Blazing Saddle in all its glory.

Once I scratched my way up to the saddle, the slope lessened dramatically and the walking became much easier. The moment I saw the place, I knew we would find some grouse. It just had that look.

In the chapter "Dusty Boy: Perfect Memories and an Imperfect Bird Dog" in *Roadside Revelations*, I wrote the following about our first experience in this covert:

> *In November of that same year, we returned to Grouse Rock and again hunted the opposite side. We came into this* birdy-looking saddle and Dusty struck a nice point in a berry bush, but this time his tail did not flag. Remembering my lesson from earlier, I honored Dusty's point and a ruffed grouse got up in front of me. I whiffed my first chance, not once but *twice, but marked the bird down. On the second flush, I missed again, swung hard, and caught the bird just before it tried to duck behind a huge pine tree. Despite my poor shooting, I count this as a bird taken from one of Dusty's points. I named this covert, "Blazing Saddle," because of all the powder I burned trying to harvest a bird over Dusty.*

White Dog by M.R. Thompson. *www.uplandart.com.*

Ever since this experience, this covert has held a special place in my heart, but I have only been able to hunt it a few times over the last decade.

In October 2013, I hunted the Blazing Saddle during my weeklong hunting excursion with my brother Shawn and author Tom Davis. That week, the hunting was the toughest we had experienced since 2008, not to

mention that I was suffering from a shooting slump. On the last day, I took the opportunity to roam this covert once again. Here's my journal entry from this day:

> *For our last hunt, we went to Grouse Rock, but I wanted to hunt the Blazing Saddle for old time's sake. Tom Davis and Shawn hunted up a draw running parallel to Grouse Rock. I offered to have Tom or John (the New York photographer) come with me, but when they saw the steep terrain, they wanted none of it, which honestly, was fine with me. Admittedly, it was a bugger to get up there, but it was so darn beautiful. Misty and I worked our way over to the saddle and it was in its full glory with its quakies ablaze and looked as birdy as ever. As we worked through the saddle downhill, I remembered my first time there and actually pointed out where I finally overtook that bird with Dusty and Sunny all those years ago…good memories! When we stepped out of the saddle and into the service berry trees on the bench, Misty swung around the edge of the big wooded draw and kicked up a thunderous grouse that flew right in front of me, which I missed twice. I'm starting to think that lately Misty is pushing these birds to me on purpose. However, those shots where the bird flies right at me or crosses directly in front of me are tough. The unruffled grouse dropped back into the saddle and we pursued in hopes of another opportunity. Once inside the saddle, we worked up to the top of the covert and Misty swung to my right and then pointed briefly and the nervous ruff blasted out of the cover quartering right to left. With my confidence lacking, I tried to get on the bird, but ended up shooting behind it.*

This was my last chance at a bird for the week, and I blew it. In my younger years, misses like these used to really eat at me, but not anymore. I guess that comes with time. This is actually a great memory for me. In my journal, I summed up my sentiments on this tough week of hunting:

> *It was good to be with my brother and our friend, Sterling, in beautiful country with our dogs. That alone, is worth the price of admission.*

> *The hunt helped me to appreciate just how good we had it in 2010, 2011, and 2012. We have been blessed!*

> *We ate delicious food every day. Any week you eat tacos/Mexican food four times is awesome.*

I loved being in the outdoors during the best time of the year. The colors, the lighting, the temperature, the taste of frost-ripened apples, are all good for the soul.

I got to remember hunts from years past and to tread the same paths my dogs and I walked in our younger days.

I was humbled by my shooting and realized that shooting slumps are part of the game and I learned to say: "This too shall pass."

I realized that, even without birds, a hunt can still be a good experience. As Sterling so aptly put it: "It's just another birdless day in paradise."

Birds or no birds, any day in the grouse woods with bird dogs is one to be cherished, especially in a place like the Blazing Saddle.

Chapter 21
THE GARAGE BAND

If a man does not keep pace with his companions, perhaps it is because he hears a different drummer. Let him step to the music which he hears, however measured or far away.
—Henry David Thoreau

The classic scene in upland bird hunting has to be the dog quartering perfectly before the gunner with the bell around its neck tinkling as the dog works the cover. Bright light pierces through the forest canopy like the lights of a stage. As the dog hits the invisible thread of scent, her whole body wiggles in excitement with that unmistakable birdiness as the dog zeroes in on the source. Her choke-bore nose locates the source, and her body stiffens with her nose thrust directly toward the invisible bird. The tail that once wagged like a child's sparkler now sticks up ramrod straight. With a smile on his face, the gunner walks past his four-legged companion and kicks up a thunderous ruffed grouse, which presents an easy straightaway shot. The confident gunner smoothly mounts his gun and pulls the trigger, and the bird drops in a cloud of feathers. The dog, which had been perfectly steady to wing and shot, upon his master's command, retrieves the bird to hand.

I like to think of such dogs and gunners as rock stars. The hunter is like U2's Bono singing "Bullet the Blue Sky," and the dog and its work are like the Edge with the perfect riff.

Unfortunately, that's *not* me and my Brittanys. We're more like a garage band. Think of the Presidents of the United States singing "Peaches" with their crunchy guitars. Let me give you a few examples from my journal of what I mean. On Thursday, October 10, 2013, I wrote this about hunting ruffed grouse at my favorite covert, the Royal Macnab:

> *I decided to take Misty up to the treeline to try and find Ol' Ruff. My goal was to hunt my way over to this sweet little, quakie-choked finger of the furthest draw on the southern edge of the property that I had admired earlier. I hunted through the thick timber toward the draw, and though the fall colors were stunning, we found no birds. When I reached the farthest draw, I crossed over on this logging road that I had never been on before. Still no birds. Where the far draw began to narrow, Misty got birdy in a small quakie thicket. I thought I heard a bird flush, but didn't see anything. However, Misty was looking up into the trees. I went down to her and looked for the silhouette of a ruffie in the trees, but could not see anything in the sea of golden leaves. I even shook a few trees but to no avail.*
>
> *So I stepped out of the thicket above the draw to see if I could catch a glimpse of the bird Misty was sure was there. I still couldn't see anything and was about to leave when Misty did something I've never seen her do before. She had observed me shaking the trees and she then put her paws up on this small quakie and barked and shook the tree. I knew something special was happening. I walked toward her. Misty jumped up and did it again and sure enough, Ol' Ruff blasted downhill out of that little tree. I fired at the disappearing blur and watched my shot rip through the golden canopy as I swung the gun downward. The shot felt good and I even told Misty to hunt "Dead bird!" We searched for about five minutes, but found no bird or any sign that I had hit it. I was very pleased with Misty's performance despite my poor shooting.*

I think the tune we played that gorgeous fall day was the Presidents of the United States' "Lump," but the words were: "It's slump, It's slump, It's slump. It's in my head…"

On November 2, 2013, my bandmates and I had another less-than-perfect hunt in the Outhouse, which name admittedly seems kind of fitting for a garage band:

> *After our first few hunts, we decided to try the Outhouse Covert one final time this season. We hiked up the narrow road and right by the Outhouse,*

Misty bumped a grouse which I marked down. I followed its line of flight, but Misty, the turd, got to it first and bumped it again. This time, however, it flew into a tree. I tried to position myself for a good shot, but, in the best location, the harsh sunlight was blinding. So I stood to the right of the tree and threw a few sticks to try and make the grouse fly. After the third throw, the grouse flushed hard attempting to cross the clearing over the road. I raised the gun and pulled the trigger before the gun even hit my shoulder and was sure that I had missed. But to my utter amazement, the bird cartwheeled in the air and landed in the creek. Sunny Girl made a nice retrieve of a rare, beautiful red-phased ruffie. What a crazy, lucky shot!

Perhaps Filter's song "Hey Man, Nice Shot" was our little ditty that frosty morning.

As these journal entries show, like the music of a garage band, sometimes hunting with my dogs is not pretty. However, it is usually exciting and fun. And in the midst of all that cacophony, we often find a tune where it all comes together and we get'r done. I guess we can't all be rock stars, but that doesn't mean we can't still make music.

Chapter 22

OF HEARTH AND HOME

To be admitted to Nature's hearth costs nothing. None is excluded, but excludes himself. You have only to push aside the curtain.
—*Henry David Thoreau*

Every so often, a hunter stumbles upon a place that really speaks to him, a place where he feels connected to Nature, Nature's Creator and the history of the area. I found such a place during the fall of 2013. I first hunted this little valley in eastern Idaho in early November. The small draw with its tiny spring feeding into Trickle Creek caught my attention in warmer days, but for one reason or another, I never took the time to explore it before then. With a grouse already in the bag from the Outhouse Covert that brisk morning, I was ready to explore.

On the right-hand, north-facing side of the draw are Douglas firs, or "dark timber," as we call it, and in the creek bottom are willows and quaking aspens. Grazing cattle have thinned much of the cover in the bottom, but the left side of the valley still contains plenty of thick, broomstick quakies that will knock your hat off if you are not careful. Up farther on the south-facing slope is a rocky outcropping with jagged spires surrounded by sage, buck brush and a few cedar trees. I definitely liked what I saw.

The dogs and I made our way about three-quarters of a mile up the draw to what I thought was an old beaver dam that had silted up to the point where it no longer held much water. Nevertheless, the earthen bank

testified that in the past there was some sort of dam and pond there. In my experience, beavers and grouse make good neighbors, as grouse take advantage of the diverse-aged forests that beavers create by their industry. This made me like this area even more.

Although the little idyllic valley, its rocky outcropping and the birdy-looking cover called me onward, I had promised Kristin I would be home by noon, and I intended to keep my promise. The rest of this valley would have to wait for another day. On our way back down, Misty bumped a ruffed grouse into a nearby quakie, and when I pitched a stick for the reflush, the bird used the cover to its advantage and burned my biscuits. Of course, I gave it the two-barrel salute. Oh well, one bird in the bag was plenty.

A few weeks later, I was able to return to this same valley. I talked my good friend Scott Johnson and his son Cole into chasing grouse in the December cold. A fresh blanket of about four inches of powdery snow covered everything except the steep south-facing slopes, and the creek itself was totally frozen over. Although it was cold, we were dressed for it, and the going was easy, although little Cole slipped and fell once or twice along the way.

Scott agreed with me that the cover looked birdy and was surprised that our dogs did not find any birds in the likely places. We made our way up to the old dam site and kept going up the trail. Just around the bend, we observed a small old cabin up against the mountain side. For me, this sight was totally unexpected. Of course, we had to check it out and take some pictures. As a lover of grouse-hunting literature, this site kind of reminded me of the old cellar holes, stone walls and apple orchards hunters stumble upon back east.

Over time, the cabin has slumped to the left. Although the metal roof still held fast, the wood siding had fallen off in a few areas. Nevertheless, the inside was still mostly dry and protected from the elements. The front door was no longer there. Upon stepping inside, we noticed a stone fireplace with a metal stove pipe in the left corner near the door. The cabin itself was neat, but the hearth brought a whole new dimension to the rustic structure. Whoever built this fireplace took great care to create something that would last. Whether it was his home or just the place he went to get away, the owner truly loved this place. Scott and I commented that we could still build a fire in this old hearth and feel totally safe within the structure.

We left this special cabin as we found it and continued up the draw. Only twenty-five yards away, however, we came across a spring that came

Andy, Misty, Cole Johnson and Gunner pose in front of the old cabin with the stone hearth.

right out of the mountainside, which was the headwaters of the little spring creek that flowed down through the narrow valley. Where the creek had been totally frozen over down lower, here it was free flowing, and its green watercress contrasted starkly with the snowy white background. With the discovery of the spring, I immediately realized that the cabin's location was chosen because of its proximity to this ever-flowing, pure water.

 Soon I put two and two together and realized that the old dam a hundred yards down the valley was not a beaver dam at all but was likely the handiwork of the same individual who built this cabin and its quaint hearth. He probably created the pond primarily to water his cattle, but I wondered if he was also a fisherman and if the now-gone pond once held Yellowstone cutthroat, which are abundant in Trickle Creek downstream. I wondered if the man ever walked the old trail along the creek with a double gun hoping for a grouse to fly or watched, with rifle in hand, the south-facing hillside and the pond hoping for a nice muley buck to come to water.

Ella's Grouse by Jason S. Dowd. *www.uplandlowlife.com*.

I soon felt a kinship to this person, whoever he was. He must have loved the great outdoors for many of the same reasons that I do today. Although he probably did not have much by way of material possessions, he had all that he needed. In fact, to live in such a beautiful place, he must have felt like a rich man. This was his little piece of heaven. As I've fished Trickle Creek and hunted my numerous grouse coverts in this area with

my Brittanys, I, too, have felt extremely blessed to have such places so close to home.

Although we did not see any grouse that December morning, we thoroughly enjoyed ourselves. As we headed back to the car, I commented to Scott, "I think I will name this covert 'Hearth and Home.'" This was the only name that captured all of my sentiments on this place. I will definitely go back in the future to discover more of its closely held secrets.

Chapter 23
THE SONG OF HARVEST HOME

Gratitude is the sign of noble souls.
—*Aesop*

Our rich ruffed grouse hunting tradition is deeply rooted in the eastern United States and is spreading across the country into the Rocky Mountains. Wherever we live, we grouse hunters have much to be grateful for. On Thanksgiving Day, I can think of no better tradition than to go afield in pursuit of our favorite game bird, especially when we have the opportunity to introduce a new hunter to this grand sporting tradition.

I was pretty excited on Wednesday night when my good friend Scott Johnson agreed to go grouse hunting on Thanksgiving morning of 2013. Before I picked up Scott on Thursday morning, I did not know that his eleven-year-old son Cole was coming, but I was glad he did. On opening day in late August, we took Cole forest grouse hunting and—though we found a few birds that day—Cole had no opportunities to take his first grouse. Our plan was to hunt a new area in eastern Idaho not far from home that Scott had discovered while deer hunting in October. Along for the hunt were my Brittanys, Sunny and Misty, and Scott's chocolate Lab, Gunner.

It took us a while to find the road, but once we located the general area, Scott couldn't remember the exact spot he wanted us to try. So we settled for a willow-lined creek bottom at the end of a dirt road. At first glance, the cover did not particularly strike me as birdy-looking because the north-

facing hillside of the narrow valley on our right held mature Douglas fir pine trees—or dark timber—which usually isn't the best habitat for ruffed grouse. But with time ticking away, we felt it important to start hunting, come what may. I thought to myself, *If we can only get Cole his first bird, this will be enough.*

As we walked up the snow-covered trail about seventy-five yards, my American Brittany, Misty, worked the willow-choked creek bottom out of view, and her bell suddenly went silent. Sunny Girl, my aging French Brittany on the trail ahead of us, pointed, honoring Misty.

Surprised, I looked at Scott and Cole and proclaimed, "Sunny is on point!"

No sooner had I said this than multiple birds boiled out of the thick cover. One landed in a tree along the trail. Another gave me a nice quartering shot, which I flubbed twice.

As a rule, Scott and I only take birds on the wing. However, we make an exception when we take a youngster hunting for the first time. In this situation, we allow the new hunter to shoot a sitting bird so they can experience some success. We figure that it is only a matter of time before they realize that it is more challenging and exciting to take them on the wing.

With a grouse in the tree ahead of us, we walked to about twenty yards from the target. Cole then pointed and shot his tiny .410 but missed the sitting grouse, which hopped outward on the limb and then flew straightaway uphill. Of course, I was there to back him up and shot twice at the departing grouse, seeing no signs that I had hit it. So I did not follow up as I should have. Instead, Cole and I continued to hike up the trail while Scott worked the left-hand side of the creek.

Scott had marked down fairly accurately where one of the first grouse had landed. So we all pushed toward this area. Gunner, the Labrador, briefly pointed, and as I passed him, a bird flushed behind me into the dark timber without presenting a shot.

As Cole and I continued up the trail, the dogs raised another grouse out of the creek bottom, and it flew into a tree ahead of us. We gave Cole a second chance, and this time he made a better shot, but the bird was only winged. My Misty chased the grouse down and brought it back but dropped it at my feet, only to have it run off again. Misty ran after it and retrieved it again with the same result, except this time the grouse ran down the hill toward the creek. Gunner and Sunny charged after it—with Gunner beating the old-timer—and finally retrieved the grouse to hand. Cole now had his very first grouse! The morning was already a tremendous

Left: Cole Johnson holds up his first grouse ever.

Below: Cole is so proud of his brace of grouse.

success (despite my own poor shooting). I took a few photos with Cole and his first grouse.

About thirty yards up the snowy trail, I observed fresh grouse tracks going down into the willows. I called out to Scott across the creek, "There's a grouse right down here. Get ready!"

I sent energetic Misty into the creek bottom to do the brush-bustin', and a grouse flushed up into a tree about twenty yards ahead of where Cole and I stood. A split second later, another grouse flushed hard behind me heading for the dark timber, and I spun and swung ahead of it. The shot felt good, but Scott also shot at the same bird only milliseconds later. With all the lead in the air, the bird fell solidly to the ground. We called it a "double" and were both glad to take this beautiful bird on the wing.

As for the bird in the tree, Cole had the opportunity to take his second bird. This time, Cole's shot was right on the money, and Gunner quickly retrieved the beautiful ruffie to hand. Scott came over to the trail, and we stopped to take some beautiful photos of Cole with his first two grouse.

It's amazing what a few birds in the bag does for the psyche and to one's perception of a piece of cover. With our success, I began to see this covert in a new light and to recognize its draw to the birds. Grouse used the dark timber on the right-hand side of the valley for roosting at night and the willow clusters in the creek bottom for budding in the morning. By sheer luck, we happened upon the perfect set-up for late-season grouse hunting. We later worked some other areas on the left-hand side of the little valley with quaking aspen thickets, which are usually good grouse cover in the early season, but we did not move a single bird. This only solidified my theory regarding the grouse's preference for the creek bottom and the adjacent pine-covered hillside in the winter.

Around 11:00 a.m., it was time to head home to our families for the holiday festivities. To get back to the car, we hiked back down the same trail that we had used earlier. Gunner, who had hunted fairly close all morning, was soon out of sight. I didn't notice, but Scott watched him work uphill into the dark timber. As we got about seventy-five yards from the car—where the action first began that morning—Gunner suddenly appeared on the trail walking toward us with a grouse in his mouth.

Upon bringing this bonus bird to hand, it was cold to the touch. Putting two and two together, we deduced that this was the second grouse that I shot at as it flushed straightaway out of the tree. I immediately realized that even though I thought I had missed, I should have followed up after the bird. To our amazement, Gunner Boy had found and retrieved this bird nearly two

The Heartbeat of the Woods

The author with a nice ruffed grouse pointed and retrieved by Sunny Girl.

hours later. I was ecstatic. Suddenly, my shooting for the day was not so bad after all. Scott described Gunner's finding and retrieving the bird as a "little redemption" for me, and I could not disagree.

Because of inclement weather, late November grouse hunting in Idaho can be a hit-or-miss proposition (no pun intended). Oftentimes, a hunter is locked out of his coverts by Ol' Man Winter way before the season is officially over. Yet I could not have picked a better morning or place to go grouse hunting with a great friend and his young son. The words of the hymn sum up nicely my sentiments for the hunt that crisp Thanksgiving morning:

> *Come ye thankful people come; Raise the song of harvest home.*
> *All is safely gathered in, Ere the winter storms begin.*

Chapter 24

A MATTER OF LIFE AND DEATH

It's a dangerous business...going out your door. You step onto the road, and if you don't keep your feet, there's no knowing where you might be swept off to.
—*J.R.R. Tolkien,* The Lord of the Rings

For those who hunt, they understand that hunting is a matter of life or death for the quarry we pursue. However, the hunter is rarely on the receiving end of a life-threatening risk. On Monday, September 1, 2014, Labor Day, I experienced a hunt where my life was truly endangered.

I hunted alone that morning with my Brittanys, Sunny and Misty. I had asked a few friends to come along, but—for one reason or another—none of them could come. I do not mind hunting alone with my dogs, as I truly enjoy their company. We had a great morning of finding birds in the Outhouse Covert, but Misty was a bit keyed up and bumped many blue grouse without giving me any great shots. I jokingly named this special covert the Outhouse because that is where you go when you shoot like crap. Admittedly, my shooting that morning lived up to this covert's name.

For our last hunt, I decided to hunt Grouseketeer, an old logging road cutting across a steep timbered ridge, which has been my best blue grouse covert since 2006. In my experience, this covert really shines between 9:00 a.m. and 10:30 a.m., as the birds are actively moving about and feeding during this time. Over the years of hunting this covert, I have never experienced anything that I would consider dangerous or life-threatening. In fact, the thought had never even crossed my mind before this morning.

The Heartbeat of the Woods

The dogs and I headed up the old logging road to where I have found grouse repeatedly over the years. As if on cue, a large covey of ruffed grouse started flushing off the downhill side of the logging road. Never having seen ruffs in the area before, the dogs and I pursued. I missed one bird that flew behind a tree and shot at another one that I thought I might have hit. As we went down the steep hillside, however, I spotted the grouse sitting in the tree and realized that I had missed. I will not shoot a sitting grouse, but I'm not above pitching sticks to get the bird to fly. This is a tough shot for one who is both the thrower and the shooter.

I picked up a stick and threw it into the tree, and the next thing I knew, I heard this loud buzzing all around my head and upper body. I instantly realized that I was being attacked by a swarm of hornets as they repeatedly stung me on my neck, head, face and back. I ran back uphill as fast as I could, screaming in pain and panic. I must have been stung ten to twenty times. As I reached a little switchback that leads up to the main logging road, one final hornet stung me on my arm, and I quickly brushed it away. To my relief, the rest of the swarm was gone.

While I was still in pain from the stings, I did not think that I would have an allergic reaction, as I have been stung by hornets before with no complications. So I decided to shake it off and keep hunting. The dogs and I walked another fifty yards up the logging road, and Misty suddenly became birdy near the uphill embankment—again at another place where the dogs have regularly found blues over the years. There was no question in my mind that Misty was working a bird, and I readied myself for the shot as she climbed up the steep embankment.

Shortly thereafter, Misty flushed the blue grouse across the logging road in my direction. I missed the crossing shot but caught the bird as it dove down the hill. I hiked downhill, and Sunny—who was twelve at the time—located the bird under a thick tree and made a nice, but slow, retrieve.

By the time I made it back up to the logging road, my feet had begun to itch uncontrollably. I quickly realized that I was having an allergic reaction to the hornet stings. I stopped and took a few pictures of the bird, hoping this unpleasant itch would go away. Soon, however, my hands and then my whole body started to itch with a vengeance.

At that point, I realized I was in trouble and started to panic. Fortunately, I had cell service, and I called my wife, Kristin, and informed her, "I just got stung by twenty hornets. I'm having an allergic reaction. I need you to get me some Benadryl. I'm coming home right now." I was having a hard time speaking because I was hyperventilating.

Right: The hornets' nest was well hidden in the quakies.

Below: Misty points a blue grouse not far from where this harrowing experience took place.

The dogs and I hustled back to my Honda CRV. In that one-hundred-yard walk, my symptoms went from bad to worse, and I began to feel lightheaded and experienced chest pains. I called Kristin again and asked her to start driving toward me with some Benadryl. My speech was even more strained during this second call. I shakily loaded the dogs and started driving down the steep canyon road.

In my dire circumstances, I offered up a quick, simple prayer: "Please help me, Heavenly Father, don't let me die now! Help me to drive safely and get some help. In the name of Jesus Christ, amen."

I managed to stay conscious and keep the car on the road, although with some difficulty. Fortunately, there were no other cars on the lonely canyon road. To my consternation, I felt and watched my face swelling in the rearview mirror as I traveled.

I soon hit pavement and drove another two to three miles down the road when a first-response medic passed me with his sirens on. Somehow, I knew that Kristin had called 911 and that he had come to help me. I pulled over, and he stopped and asked me, "Are you the guy who got stung by the hornets?"

"I am. Man, am I glad to see you!" I responded.

He asked me to pull my car over to get out of the way of oncoming traffic and had me sit on the ground while he checked my vitals. As he did so, I started to blackout and said, "I'm not feeling so good. I need to lie down," which he encouraged me to do.

My wife, Kristin, and our oldest daughter, Emma, soon showed up, and when Kristin saw me lying helpless on the shoulder of the road, she cried. She handed me a bottle of Benadryl, and I lifted my head, took a swig and laid back down. The medic also gave me some oxygen through a nose tube.

The medic then checked my blood pressure and found it was extremely low. I told the medic that I thought I could sit up again, and he said, "Stay put. I don't think you are doing as well as you think you are doing. You are going into anaphylactic shock." Looking back, I can see that the timing of his arrival in comparison to my worsening condition could not have been more providential.

An ambulance soon showed up with two other paramedics, and they gave me a shot of Benadryl and a shot of epinephrine. One paramedic commented that I was exhibiting the textbook signs for an allergic reaction to hornet stings just like he learned about in school. They encouraged me to ride in the ambulance to the hospital, which I agreed to do. Kristin and

Emma then took my car and the dogs home and told me they would meet me at the hospital.

The ambulance drive was surreal as I watched out the back window the beautiful country surroundings we passed by. I thought to myself, *I never thought I'd see things out of the back of an ambulance.*

As we traveled, one of the paramedics commented that he was worried about me when he saw the swelling in my face. He told me about one of his wife's family members who recently died from an allergic reaction to a hornet sting he received in the mountains and being too far away from medical help to save him. This unfortunate individual did not even know he was allergic before this fateful day. To my relief, the paramedic told me that the Benadryl and epinephrine were working and the swelling in my face had already subsided. Likewise, the itching was gone. I somehow knew I was going to be okay.

My stay at the hospital was short-lived, and my wife and kids soon came to take me home. My kids had made me some get-well cards, which were touching. I was truly relieved to see them all. More than once, I stated out loud how grateful I was to be alive.

I'm a firm believer in the Boy Scout motto: "Be prepared." I am happy to report that from now on, I will carry Benadryl and EpiPens with me when I am hunting. Likewise, there's much to be said about hunting with a good hunting companion who can help you when you are in a bind. Also, I now see the importance of letting your spouse know exactly where you are hunting in case you run into trouble.

In addition to these safeguards—and even more important—I can honestly attest after this harrowing experience that I will never forget the power of prayer. I truly believe that God heard and answered my prayers. Throughout this whole ordeal, I know I had heavenly help from the other side.

Chapter 25

NO SENSE TO COME IN OUT OF THE RAIN

The best thing one can do when it's raining is to let it rain.
—Henry Wadsworth Longfellow

The preceding week in September 2014 had been crazy busy at work, and I had no time to get out hunting with the dogs, which was kind of a bummer because the weather was the bluebird kind that we bird hunters live for. So I planned to hunt Saturday morning. Problem was that the forecast for the weekend was nonstop rain. In fact, not long after I got off work on Friday, the storm clouds rolled in and the rains poured down with a vengeance.

Early Saturday morning as I listened to the rain, I questioned whether or not to go hunting. In my younger days, I would have gone come hell or high water. But more recently, I have felt that, if I have the choice, I would rather hunt in better weather.

At 7:47 a.m., brother Shawn texted me from Colorado: "You hunting today?"

I replied, "Not sure…it's freaking raining."

"I hate rain!" Shawn responded.

"It rained hard all night. I may still go," I wrote back.

"Kill a wet one!" Shawn challenged.

"I wanted to go to Grouse Springs, but the roads will be crappy. Guess I'll hunt up on Grouseketeer Ridge…I'm going hunting!" I finally asserted determinedly.

Idaho Ruffed Grouse Hunting

When I finally got on the road a little after 8:00 a.m., I questioned my decision as the rain poured down, creating big puddles in the road and swamps in the farmers' plowed fields. But I kept driving, hoping to find a break in the clouds. If nothing else, I would have a nice drive in some beautiful country.

By the time I reached Grouseketeer Ridge, the rain was only a drizzle, but one that could get you nice and wet in a hurry without the right gear. So I donned my rain jacket and Wick Chaps.

The dogs and I hiked fifty yards up the logging road, and I quickly saw a ruffed grouse running in the timber above the steep embankment on the uphill side of the road. I sent Misty up the embankment, and she made a nice flash point. The bird then flushed low, and I fired a shot through the thick timber without any results. To my chagrin, the bird landed in a nearby pine tree. Try as I may, I could not get a stick up there to make it flush. So I decided to keep hunting up the ridge.

We reached the fork in the road and took the short fork to the left that heads up to "Rock Heaven," which my daughter Eden named, quite simply, because the trail is *rocky* and the view is *heavenly*. The name just sort of stuck. Misty worked the steep hillside above the road and bumped one, maybe two, blue grouse, which flew high up into the nearest Douglas fir.

"Misty, you hold 'em!" I commanded in frustration. I repeated this phrase a few times, hoping to get it through her thick skull that I wasn't pleased with her performance.

We then headed across Grouseketeer Ridge, through a cut in the mountain and up the old two-track leading to Dusty's Nub, a sage and buckbrush–covered hill above the tree line. At this high elevation, we were right up in the wispy clouds, which blew by us as the rain steadily fell. On rainy days in the past, I have found birds right up on the Nub, so I was hopeful despite the foul weather.

As we worked through the sagebrush, a little song bird got up, which almost caused me to raise my gun in excitement. I said out loud, "You are lucky I know the difference between a blue grouse and a Tweety bird!"

On high alert, I walked about ten more steps, and a big blue flushed ahead, giving me a nice straightaway that I made good on. Misty made it to the downed bird first, but she just stood over it, and the old-timer Sunny Girl stepped in and made the retrieve. I was instantly glad I braved the elements.

We then turned around and headed back down Grouseketeer Ridge hoping to find another bird. At the same area where we had earlier found Ol' Ruff, Misty pointed again, but the bird did not hold long, and my

rushed shot missed its mark through the dense forest. Still, Misty's point was beautiful and fun to see. She had finally got my pointing memo.

We walked around the bend and headed up a logging road I call "the Steps" because in this area the logging road switchbacks back and forth, creating successive steps up the mountain. Misty again locked up on point on the downhill side of the road, with Sunny Girl honoring. Paraphrasing Howard Cosell, "Now that was a sight to behold!" Before I could get into good position, however, Misty quickly moved forward and flushed the bird, which landed in a nearby tree. I pitched a few sticks and then missed the difficult diving shot such tactics usually produce.

Again, I sternly told Misty, "You hold 'em!" Had she held for just another second or two, I would have been in great position to take that bird—or at least to have a better shot.

We hunted the Steps for a while longer but decided to try our luck at the Outhouse, which has been my most productive covert over the last few years. When we reached the gate into the narrow valley leading to the Outhouse, it was still raining. Nevertheless, the dogs and I headed up the two-track into the narrow valley.

As we walked, Misty hunted the quakies on the left-hand side of the road. About two hundred yards up the road, Misty became birdy and then stretched out into a beautiful point. I walked quickly toward her, but she did not move. I then made the mistake of looking on the ground to where Misty was looking and saw the ruffie walking slowly away. For whatever reason, I have a tough time making the shot when I see the bird on the ground. When the bird finally flushed, I missed it the first time but recovered on the second shot.

"Good girl, Misty!" I stated, pleased as a peach.

At my shots, two other birds flushed. One landed in a nearby tree, and as I walked toward it, the bird flushed hard straightaway and then juked up and to the right. I missed with the bottom barrel but then corrected and took the bird with the top. Misty chased down the winged bird and made a great retrieve.

Misty went on to point two more ruffed grouse in the Outhouse—one at which I had no shot and one at which I had a tough shot through thick timber—and a blue grouse, which Sunny Girl backed her on. I had only a fleeting quick snap shot at the blue grouse but did not connect. If only my shooting had lived up to Misty's stellar performance!

By the time we hiked out of the Outhouse, I was soaked, despite my raincoat and chaps. There's an old saying about having no sense to come

in out of the rain. Before this rainy Saturday, I might have agreed with that saying, but now I'm a fan of hunting in the rain. This was, by far, one of my most productive days of bird hunting in 2014, and at four years old, Misty hunted better than she ever had before. What a morning!

Chapter 26
WE ONLY GET SO MANY OCTOBER DAYS

I never lost a moment's time in hunting....I counted only that time lost which I spent working.
—*Burton Spiller*

It's Friday morning, and I am tired of working. Any week in the practice of law always carries with it the attendant negativity and stress. So when noontime rolls around, I call it good and sneak away for the rest of the day. After a Mexican feast with an old friend, I run home to change into my hunting clothes and pick up my dogs, Sunny and Misty.

We head east toward our grouse coverts listening to good tunes and enjoying the grandeur of fall's beauty. With the warm sun shining, it truly feels like a day in late September rather than mid-October. To be sitting in an office on this glorious afternoon would be a crying shame.

The dogs and I first head to a covert we have not yet tried this season. I hope to find a ruffed grouse or two along an old logging road not far from a creek bottom. We soon find where a ruffie had recently been ambushed by a predator but find no living birds. No problem; we still have plenty of daylight.

Our next stop is Grouseketeer Ridge. I do not expect to see any blue grouse but hope to find the ruffies that led me into the hornets' den back in September. As we approach the area where we had unexpectedly found those ruffs in early September, a grouse flushes and lands in a tree. Surprisingly, it is a blue grouse. I have never seen blues on this ridge

Sunny Girl waits for the author at the mouth of the Outhouse covert.

in Octobers past. I walk briskly toward this wary grouse, and it flushes straightaway, giving me an easy shot, which I make on the second try. As the dogs retrieve the downed grouse, another one flushes unexpectedly. I think to myself, *What are blues doing on this ridge in October?*

As we walk up the logging road about twenty-five yards, Misty points on the downhill edge. Another blue grouse rises straight up, and I shoot under it, both times cursing myself for missing an easy shot over a nice point. At this point, I realize that something special is happening on Grouseketeer Ridge. I leave this blue sitting in the tree for seed, believing that we will get some sportier opportunities.

Ahead of us on the trail, I see two more blues on the edge of the logging road. I command Misty to heel, and we walk briskly toward them, but they flush before we can get into shooting range. Man, there is a pile of birds on Grouseketeer Ridge, even more than on the day it earned its name!

As we walk up the steep incline to where the logging road forks, we take the left fork up to Rock Heaven. Somehow, I just know we will see birds up by the mountain ash thickets. Sure enough, I spy one grouse standing on the road's edge right above the mountain ash. I command Misty to heel, and we briskly walk toward the big grouse. It flushes hard downhill, and I swing hard and catch the bird before it makes it behind a tree. To my surprise, another grouse flushes only nanoseconds after the first, and I swing on it too but miss the chance for a double. We struggle through the thicket to locate the first downed grouse, which is only winged. Misty makes a nice retrieve but will not bring the bird to hand. When she drops it, Sunny Girl swoops in and finishes the job. With two grouse in the bag, the day is already a stellar success. We follow the road through Rock Heaven up to the overlook, and the view is stunning as always, but we find no more grouse.

So we head back down to the fork and along the rest of Grouseketeer Ridge. As we walk, two more blues flush wild, offering no shots. I again leave birds sitting in trees hoping for better opportunities. Fifty yards farther up the road, Misty flushes a few more blues out of range. At the big switchback leading up to the Gap—a road cut crossways through the spine of the mountain—patient Sunny Girl finds and points a grouse. I am happy as a lark as I walk toward her. However, the blue flushes behind her, and I miss with both barrels. I tug the trigger a third time to no avail, thinking, *Darn it! Now I've missed two birds over points!*

We find no more birds on Grouseketeer Ridge, Dusty's Nub or the Steps, but I can honestly say I've never seen more birds on this mountain, even in September when it really shines.

Idaho Ruffed Grouse Hunting

For our last hunt, we drive down the road to the Outhouse, which has been one of my most productive coverts for the past two seasons. The entrance to this special covert is decked out in a blaze of fall colors that would put a smile on any grouse hunter's face. The dogs love it too. With two blues already in my bag, my goal is to find a ruffed grouse.

About one hundred yards up the road, Misty flushes a few blue grouse out of range. I take a poke at one but miss.

Bounties from the Beaver Meadows.

The Heartbeat of the Woods

We reach an area where a downed tree blocks the road. A grouse flushes hard straightaway from under the fallen tree, and I miss it twice as it disappears up the road. I am certain that we can find this grouse again.

Another seventy-five yards up the road, Misty gets birdy and then follows scent into the thick chokecherry thicket on the hillside above the road. I know she is on a bird, and when it finally flushes in the thicket, I shoot at the blur passing through the timber, feeling like I am behind when I pull the trigger. To my surprise, the grouse drops and then rolls head over heels down to the roadway I am standing on. Sunny retrieves it, and I notice it is a beautiful, mature, gray-phased ruffed grouse cock. I am so stoked by the dog work, my lucky shooting and my good fortune.

Even though I do not yet have my limit of four birds, I decide that three is plenty. I turn back down the road and head for the car with a smile on my face. The only thing that would make this day any better is to catch a cutthroat out of Trickle Creek, and that is exactly what I plan to do with my new Badger Tenkara Rod. Once back to the car, I load up the dogs and drive up the road to fish a favorite stretch of the creek.

After stringing up the Tenkara rod, I tie on one of Shawn's Chubby Mormon Girls and start fishing the familiar water. In a deep hole, a large yellow fish rises, and I miss it. I cast the fly into the hole again, and the same big cutty rises again. I stick him, but he is off in a flash. This has to be the biggest fish I have ever seen on Trickle Creek.

In the skinny water, the fish are skittish, but I manage to catch four or five beautiful Yellowstone cutthroats, none the likes of the one that got away, but special nonetheless. My love for this special canyon, its birds, its little creek and its trout abounds.

As I drive home, the song "Little Wonders" by Rob Thomas comes on the radio. I've always loved the song, but at this moment, the lyrics seem to capture my sentiments exactly:

> *Our lives are made in these small hours*
> *These little wonders, these twists and turns of fate*
> *Time falls away but these small hours*
> *These small hours still remain*

I think to myself, *If I would have stayed at work today, I would have missed all of this beauty and excitement.* I truly feel grateful that I did not. After all, we only get so many October days.

Chapter 27
EYE OPENER IN THE BEAVER MEADOWS

The question is not what you look at, but what you see.
—Henry David Thoreau

I have been hunting a covert I named Grouse Springs for over ten years now. I usually visit once or twice a season, and it has almost always been productive. Grouse Springs consists of sage and buckbrush–covered foothills leading up to a pine-crested ridge. The face of the mountain is interspersed with shallow quakie-filled draws that usually hold ruffed grouse and sometimes a blue grouse or two. There was a time when I preferred to hunt the blues, but not anymore. Over the years, Ol' Ruff has given me plenty of good sport.

On a gorgeous Friday afternoon in mid-October 2013, I went to hunt this beloved covert for the first time that year. Its quakies had recently dropped all of their leaves, which makes for better shooting opportunities at fast-fleeing ruffs. However, I did not find any birds in Grouse Springs. I was also surprised when the dogs and I came up with a goose egg in the next draw over, Grouse Alley, which has been so consistent over the years.

Due to the lack of birds, the dogs and I pushed through other little patches of quakies that we would usually overlook with nothing to show for our efforts. I thought to myself, *Hmm…where are the birds?* The cover was noticeably drier than in years past.

When I made it back to the car, I glanced across the road at the old, battered beaver ponds, which have been pounded into the ground by the

numerous cattle that graze the area. Despite the poor shape of the cover, I noticed that the willows along the mostly dry creek were tall and healthy. Out west, ruffed grouse are sometimes called "willow grouse" because of their affinity for eating willow buds. I had never even thought about hunting the willows across the road from Grouse Springs because of the usual sad shape of the cover and the consistency of Grouse Springs and Grouse Alley.

On a whim, I cast the dogs toward the creek and the beaver ponds. The dogs and I first pushed downstream along the edge of the quakies on the other side of the ponds. The cover was marginal at best because of the extensive grazing in the area. Not finding any birds there, I decided to hunt my way back to the car right along the wall of willows growing from the dry creek bed near the road. My hunter's sixth sense kicked in, and I felt we were about to find a ruffie, despite the fact that the willows are about thirty yards from the thicker quakie-covered hillside.

Within five minutes, I heard a grouse flush, and I waited for it to make for the trees before shooting. Of course, I missed. The dogs and I followed the grouse, which soon flushed up into a tree. When I shook the tree to make it fly, the bird bolted, and I missed miserably. Despite my poor shooting, I was pleased that I had guessed right about a grouse being in the willows. To paraphrase Paul Maclean from *A River Runs Through It*, I almost felt to say: "All I need is three more years till I can think like a grouse." Admittedly, I will probably need an eternity before I can shoot ruffies consistently.

Having found a grouse, I just had to follow the beaver ponds upstream to satisfy my curiosity. The dogs and I worked our way up and found a series of mostly dry beaver ponds, which had been obliterated by cattle. As we pushed upstream, my Brittany Misty slammed on point on the edge of the quakies. As I walked toward her, a ruffed grouse flushed hard in the blinding sunlight. At the sound, I rushed my first shot and then flat out missed the second straightaway shot. I call such poor shots and missed opportunities "groaners," for obvious reasons. As I reloaded my gun, another grouse flushed close by, presenting what would have been another easy shot. I followed the second bird and shook the tree it had landed in, and it blazed out of the cover so fast I could not even get off a shot.

The dogs and I walked another twenty feet up the creek bottom, and another grouse flushed right beside me without presenting any shot but landed in a nearby tree at about eye level. Misty ran to the tree and barked excitedly, and the grouse flew up to a higher branch in the thick quakie patch. While I will not shoot a sitting grouse, I have no problem trying to make them flush for a shot. My attempts at shaking a tree and getting off a

shot, however, had not panned out so far that day. So I told Misty to shake the tree. She jumped up but could not quite reach the right tree due to the thickness of the broomstick grove. Without another solution, I grabbed the tree and shook it, and the bird flushed. I quickly raised my gun and dropped it. Though I was pleased, I would have much rather taken the earlier bird over Misty's point. Oh well, beggars can't be choosers!

The dogs and I did not find any other birds in this area. By the time I made it back to the car, it was 4:00 p.m., so I really did not have enough time to drive to another covert to get in another hunt. As I drove out to the main dirt road, I decided to continue to hunt this same creek, but higher up the drainage. I drove as far as the creek paralleled the road. When the creek veered away from the road, I decided this was as good a place as any and parked the car.

The dogs and I headed up the left-hand side of the creek as the sun began its descent in earnest. Within two minutes, Misty flushed a grouse at a spot where the quakies almost reached the willow-lined creek. This bird flew harder, higher and farther than any ruffed grouse I had ever seen. I then walked quickly toward the birdy area and watched another beautiful red-phased grouse flush silently across the creek to get away from us. Smelling the bird, Misty ran around excitedly but could not pinpoint its source.

I briskly walked upstream hoping to get across the creek for a chance at this grouse. About fifteen yards upstream, I came to an old beaver dam and easily made it across. The dogs quickly followed me. When I reached the right area, Misty circled around and went to work. One grouse got up and flew back across the creek, and I made a quick, nice shot. As I shot, another grouse flushed unexpectedly up into a nearby tree. Misty made a nice retrieve of the first grouse.

After bringing the first bird to hand, I picked up a stick and threw it at the grouse sitting atop the willows. The stick hit the branch on which the grouse sat, and it flushed hard back over the creek. I swung the gun and connected on probably the toughest shot of the day. Misty again made a nice retrieve, but instead of bringing the bird to me, she took it to elderly Sunny Girl, who then brought the bird to me. I'm not sure exactly why Misty did that but thought it may have been out of respect for the old gal. At any rate, her behavior was interesting. The bird was the mature red-phased grouse I had seen.

With the sun setting, I followed the chain of beaver ponds up another hundred yards and looked for a good place to cross over and hunt the other side down. Once across, the cover on this right side was even better.

The Heartbeat of the Woods

As I walked, another grouse unexpectedly got up at my feet and flew straightaway. I promptly blew two holes in the sky: more groaners, for sure, but a perfect way to end the hunt and to keep this grouse hunter humble.

As I drove home, I was struck by how many times I have driven past this battered creek and its chain of beaver ponds over the years, never once considering it as prime grouse habitat or taking the time to explore. However, on this day, I looked a little deeper and followed a hunch, and it paid off.

The French novelist Marcel Proust wrote something that captures the essence of this hunt: "The real voyage of discovery consists not in seeking new landscapes but in having new eyes." My eyes were definitely opened this day. While my shooting left much to be desired, this was the best day of ruffed grouse hunting I have ever experienced.

Chapter 28
EASY PICKINS' AND BUTT KICKINS'

Pride goeth before destruction, and an haughty spirit before a fall.
—Proverbs 16:18

Every hunter loves "easy pickins'"—you know, those banner days where the birds are plentiful, the shots are easy and the ol' shooting eye comes through—but even though every day afield is a blessing, most days if we see a few birds, our dogs get a nice point or we make a shot or two, we feel pretty fortunate. One of the things I love about bird hunting is that you never know what a day afield will bring.

On Saturday, November 1, 2014, I found two new coverts in a general area I have hunted in the past. I simply located a few tiny creeks aligned with willows near quaking aspens and decided to explore.

When I arrived at the first creek about 8:30 a.m., I let Misty and Sunny out of their kennel, and Misty instantly ran up to this quakie patch only twenty yards from the car and squatted to pee while looking at me with this goofy grin. No sooner had she finished than she turned 180 degrees and froze into an intense, solid point.

"Are you kidding me?" I said out loud. Sunny quickly moseyed on up behind her and honored, as if to answer my question. I never get tired of that sight!

"Woah!" I commanded as I quickly stuffed two shells in my Ruger Red Label 20 Gauge and closed the breach.

The Heartbeat of the Woods

With the gun loaded, I walked slowly toward my two Brits with high hopes. The nervous ruffie flushed hard straightaway, giving me a perfect opportunity, which I centered on the first shot. Misty retrieved the grouse but took it to elderly Sunny Girl, who finished the job.

In hand, the beautiful bird was an interesting intermediate-phased ruffed grouse, which is a true mix between a gray and a red-phased grouse. I honestly don't recall taking a grouse with such unique colors in Idaho. Taking any ruffed grouse over a point has to be the pinnacle of outdoor sports. And all of this happened within the first five minutes of the hunt.

On such occasions, one cannot help but feel a sense of pride, a feeling that you are a good hunter. On the other hand, I was tempted to call it a day because I felt that things could not get any better and I understand that "pride goeth before the fall." But my curiosity was piqued when Misty flushed another grouse in the same small quakie patch only moments later. Of course, I had to hunt this area out to see if this day would bring more easy pickins'.

I won't give you the play-by-play, but I will say that the two creek bottoms and the surrounding side draws were *loaded* with grouse. Misty had some

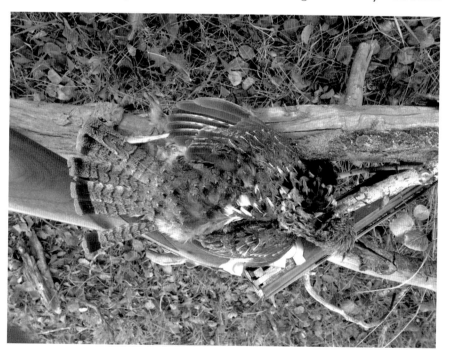

An intermediate-phased grouse, which is a mix of gray and red, taken from Easy Pickins' first thing in the morning. It was all downhill from there.

Idaho Ruffed Grouse Hunting

Misty smiles with our gray-phased ruff from Easy Pickins'

awesome points, one in which she nailed this grouse in a thick willow cluster between me and her. I missed that grouse ingloriously twice. I missed some other tough shots and I whiffed some real easy groaners. I had birds flush so unexpectedly that I could not shoot at all.

Up the second creek, Misty struck a point so stellar that I was able to look down and see the frozen ruffed grouse sitting beneath a pine bough, betrayed only by the gleam of its eye in the bright sunlight. Sunny Girl quickly backed her kennelmate. Man, how I wish I had taken a photo! But I so wanted to take this grouse over this beautiful point by my dogs. When the grouse realized the gig was up, it hopped up, ran to the far edge of the small pine and dipped down toward the creek bottom and then up the opposite hillside. To my dismay, I missed it twice.

I honestly saw more ruffed grouse in one morning than I can ever recall seeing before. However, after that first successful shot of the morning, I put on a show of total incompetence, like I had never picked up a shotgun before in my life (i.e., "What is this strange thunder stick I hold in my hand?" asked Dudley, "the Schizophrenic Wing Shooter"). To sum it up, rather than easy pickins', these grouse gave me a thorough butt kickin', and I was definitely humbled.

The Heartbeat of the Woods

But you know what? Despite the pummeling, I loved every second of this hunt. I found two new coverts with numbers of grouse that Brush Worns only dream about. My dogs' performances were not perfect, but they had some unforgettable moments. And last, but certainly not least, this hunt confirmed for me why the ruffed grouse is my favorite game bird; their ability to burn my biscuits never ceases to amaze me. I fully realize that *every* successful shot on a ruffed grouse is a *lucky* shot. Any day in the grouse woods is a good day.

So guess what I named the two small-stream coverts? Of course, the first is Easy Pickins', and the second is Butt Kickins'. I hope to make it back there for a chance at redemption. Wish me luck, my friends!

Chapter 29
LAST-HOUR GROUSE

All I want out of life is one more shot at a grouse.
—*Ray Bane, as quoted by George King in* That's Ruff!

Living in the Rocky Mountains in Idaho, you never really know when the grouse hunting season will end. Sure, the forest grouse season is open through the month of December, but when the snows come, Ol' Man Winter can shut things down quickly.

Every year, I approach the season's end with mixed emotions—a bit of melancholy knowing that I cannot pass this way again for another year—and I find myself wanting to savor every last second I spend with my bird dogs in the grouse woods.

On Saturday, November 1, 2014, I first discovered two of the best grouse coverts I have ever experienced, Easy Pickins' and Butt Kickins'. My Brittany Misty pointed a ruffie in Easy Pickins' before I could even load my shotgun. I made that first shot (there's the "Easy Pickins'") but then could not hit the backside of an elephant the rest of the day (hence the name "Butt Kickins'"). When I dream about hunting in the offseason, I'm sure it will be in these two willow-lined creek bottoms, overflowing with grouse.

I so wanted to return the following Saturday, November 8, to try these coverts again because I had left a lot of seed birds on the first hunt (if you know what I'm saying). However, I promised my mom that I would help with the estate sale of my father's extensive gun collection. As much as I wanted to be in the grouse woods, duty called, and I knew it was more important to help my mother with this difficult task.

The Heartbeat of the Woods

However, as the weekend approached, I found myself scheming a way to get back to the grouse woods, even if just for an hour. On Friday, November 7, I worked hard in the morning but left early and headed home to change clothes and load up the dogs. Sunny and Misty were anxious to go hunting too.

When we finally reached Easy Pickins' around 4:00 p.m., the sun was already beginning to set. Of this hunt, I recorded the following in my journal:

> *After I let the dogs out of their kennels, Misty blazed through the cover and we started up the creek bottom. The sound of her bell filled the grouse woods. Within the first five minutes, Misty slammed on point in an open flat along the right side of the tiny, no-named creek. I looked in the direction she pointed and saw the nervous grouse. I quickly walked toward it and contemplated jumping across the creek at one of its meanders, but, before I could do so, the bird flushed hard straightaway. I threw up the gun, tugged the trigger and the bird dropped into the tiny creek. Although Misty made it to the bird first, she would not retrieve it because elderly Sunny Girl was with us. Sunny Girl tried desperately to retrieve the bird up the creek's steep embankment on the right side, but couldn't get up it, so she turned around and crossed over to the other side. What heart! I fear that her days of hunting will soon be at an end.*

After hunting Easy Pickins', we drove to Butt Kickins', another nearby tiny creek bottom. All said, we moved about four or five grouse total, but I had no other shots. In my journal, I wrote:

> *Misty pointed a grouse near the creek in a thick berry brush below a pine tree and, as I was trying to take her photo, she broke point and a beautiful red-phased grouse, which are not as plentiful in Idaho, flushed across the creek into a tall pine tree beside me. I went and shook the tree and the bird flushed hard giving me no shot. This last hour hunt was like a pleasant dream. I savored the fall weather, the clear skies, and glorious sunset.*

The next day, I traveled to Rupert and helped with the estate sale on one of the last snow-free days of the year.

The following week, the cold and the snow came to eastern Idaho with a vengeance. By Friday, we had a good five inches in the valley. Not ready to call it quits for the year, when I saw blue skies Saturday morning, I decided to brave the elements and try to make a run for my new coverts. As I climbed the slick mountain road and the snows got deeper and deeper, I thought

about turning around and retreating for home but was scared I would get stuck if I stopped. So I stayed the course and made it safely to Easy Pickins'. However, with the elk hunting season in full swing, someone was surprisingly parked in my usual spot.

I then opted to try Butt Kickins' instead. Of this short morning hunt, I recorded the following:

> *The dogs and I hunted Butt Kickins and moved only one grouse out of the dark timber, which I never saw. The rest of the birds in the area must have still been in the roost due to the deep snow and bitter cold. Snow blanketed everything and it was so cold that ice formed in my beard. Despite the lack of success, I still enjoyed being out. To use Grampa Grouse's phrase, the landscape was a VWF, or a "Veritable Winter Fairyland." I had to be home by noon to fire up my smoker grill and cook some BBQ ribs for my family and friends.*

During the fourth weekend in November, I decided to try my luck once again, hoping to get one more shot at a grouse, except this time my good friend Scott Johnson and his son Brigham agreed to come along. Along the way, I reported to them how great these new coverts were, and they were excited to try them. Following is my account of this snowy hunt:

> *We drove up to Easy Pickins, but saw no birds except a lonely snipe in the snowy creek bottom, which I thought was odd in such a wintery landscape.*
>
> *For our last hunt, we stopped at Butt Kickins and Brigham and I took the upper left side of the creek while Scott worked the right. As we worked up the creek bottom, Misty became undeniably birdy near an elder berry bush—the exact same place she had pointed the red-phased grouse two weeks earlier. On the way in, I had challenged Brigham to only shoot a grouse on the wing. With this in mind, we sent him in for the shot and, as he approached, Misty broke and flushed the grouse. Unfortunately, Brigham missed. The bird crossed the creek and headed for the dark timbered hillside to my left. I threw up the gun, swung through the speedy grouse, and it dropped at the shot. I often miss this shot. Misty made it to the bird first, but again let Sunny make the retrieve. In hand, I found it to be the very same red-phased bird that had burned me two weeks earlier. I hooted and hollered for Misty's point and my lucky shot. This was my first and only grouse taken from Butt Kickins this year. What a perfect way to end the grouse season!*

The Heartbeat of the Woods

Left: The author's last-hour grouse. What a great way to end the hunting season!

Right: Andy and his Brittanys head for the truck on their last day of grouse hunting.

In hopes of one last hurrah, I later tried one final time to get to the grouse woods but found closed and impassable roads to my beloved coverts. My grouse-hunting season had finally ground to a halt. As I made the trek home, I sighed, smiled and thought, *It was so good while it lasted!*

The older I get, the quicker time flies. Nowhere is the saying "All good things must come to an end" more true than in grouse hunting. The trick is to soak it up, to enjoy every second while it lasts and to be grateful for every moment we spend with our dogs in the grouse woods.

Chapter 30

THE HEARTBEAT OF THE WOODS

Everybody knows...that the autumn landscape in the north woods is the land, plus a red maple, plus a ruffed grouse. In terms of conventional physics, the grouse represents only a millionth of either the mass or the energy of an acre. Yet subtract the grouse and the whole thing is dead.
—Aldo Leopold, A Sand County Almanac

Every grouse hunter comes to experience an acute love of the "grouse woods," those special coverts where we regularly find ruffed grouse. People who don't hunt grouse may consider these forests as thick, unkempt places, or maybe even inhospitable hellholes, but not the grouse hunter. This rugged wildness is the very thing that draws ruffs, for they only thrive in such places.

Earlier this spring, I spent a few hours with my family and bird dogs hiking old logging roads near some of my favorite grouse coverts. I went under the guise of seeking "exercise," but admittedly, I always hope to encounter Ol' Ruff.

One Saturday in April, we heard numerous grouse drumming in the thick quaking aspen and chokecherry–covered hillsides flanking both sides of the narrow two-track we hiked. As always, the location of the source of the strange sound was extremely difficult to pinpoint as the percussion reverberated throughout the wooded narrow canyon.

"Isn't that the coolest sound?" I asked my wife, Kristin.

Kristin—who had never heard this haunting sound before—exclaimed, "It sounds like a heartbeat!"

Her description was new to me. I always thought drumming grouse sounded like someone trying to start a motorcycle or chainsaw but not quite getting the engine to fire. However, the more I thought of her description—*a heartbeat*—the more appropriate it seemed.

Last weekend, we again headed to the mountains to explore an area where I had a hunch we'd find some good grouse cover. When we arrived, however, the day was windy and unseasonably hot for early May. Rather than drumming, any self-respecting grouse was probably loafing in the shade out of the heat and wind.

After following the switchbacks through the thick Douglas fir, mountain ash and chokecherry trees, Misty, my American Brittany, and I crested a quakie-covered, rounded knoll with voluminous trees the diameter of broomsticks that screamed of ruffed grouse. Although we didn't see any birds, I made a mental note to try back once the hunting season opened.

As I hiked back down the abandoned logging road, I reflected again on Kristin's statement: *It sounds like a heartbeat*. I concluded that this was the perfect metaphor for ruffed grouse, their drumming and their habitat. Without ruff, the woods would seem barren. I would likely not even venture into such places, as there would be no purpose.

On the other hand, with grouse, the forest instantly seems full of life and endless possibilities for beauty and excitement. A ruff grouse's drumming is the herald of spring and bears witness that life is again thriving in the woods. In the fall, the sudden thunder of a ruffed grouse's flush causes the hunter's heart to instantly flutter. A hunter never feels more alive than at the moment he gets a chance at Ol' Ruff. The ruffed grouse is more than just a mere game bird. He is the heartbeat of the woods.

Chapter 31
A GROUSE HUNTER'S DREAM

Think how pleased some old-timer would be if he knew that his pet [shotgun]
is once more someone's pride and joy.
—*Gene Hill*

Most grouse hunters are sentimentalists at heart and dream of owning a good side by side, which was the gun of choice for the old-timers around the turn of the twentieth century. The first half of the 1900s was truly the golden age for American side by sides, and companies such as Parker Brothers, L.C. Smith and A.H. Fox were producing some of the finest double guns ever made in our nation's history. It was a time when industrial efficiency and true craftsmanship were co-equals in the shotgun industry.

Around the time of World War II, Americans turned their attention to pump guns and auto-loaders, and the popularity of the side by side plummeted. In fact, most of the big-named double gun companies went under or were bought out by the bigwigs such as Marlin and Remington. The golden age had come to an end. Fortunately for grouse hunters, many excellent quality guns were made during the golden age and are still available for purchase.

When I first started grouse hunting during law school, I started with a Coast to Coast 12-gauge pump gun, and looking back, it was like carrying a railroad tie. Wanting more quickness, I moved on to a semi-auto Remington 11-87. With this gun, I gained quickness all right but missed so much more than I ever hit. Quite honestly, my third shot was almost always wasted.

The Heartbeat of the Woods

After a few years of wingshooting, I began to recognize the grace of a nice double gun, but with the load of debt from school and a growing family, any plans of upgrading were out of the question. In 2008, my generous brother Shawn gave me my first double gun, a Ruger Red Label 20 gauge over and under. I instantly loved the simplicity and beauty of this shotgun but couldn't shoot it well at first. With an adjustment to the stock length and lots of practice, however, I learned to be somewhat efficient with this gun and to make my shots count.

Nowhere is the maxim "the grass is always greener" more true than in the quest for the right shotgun. One cannot read the literature of grouse hunting without reading many references to light side by sides that are a joy to carry in the woods. While I love my RRL, I always dreamed of owning a classic grouse gun—a side by side—from the golden age of American shotguns. However, with a family of six kids and two bird dogs, the possibility of acquiring such a gun seemed out of reach financially. Moreover, the quest for the perfect grouse gun for me felt like finding the proverbial needle in a haystack. I wanted to find the best possible gun for the most reasonable price.

Fortunately, my brother Shawn has recently been bitten by the double gun bug and purchased a Parker 16-gauge at a very affordable price. Tales of the sweetness of this gun caused me to lust even more for a classic side by side of my own. And then on Friday, March 20, 2015, Shawn sent me an e-mail with a link to www.gunsamerica.com for a 20-gauge Ithaca NID, stating, "This would be nice."

I instantly followed the link and was thrilled to the core by the gun's description:

> This is a classic Ithaca light bird gun. 28" barrels are choked cylinder and cylinder. 2¾" chambers with fine bores. Star engraved receiver. 14" length of pull with a 3" drop. Weighs just over 6 pounds. About 90% wood and barrel finishes. Case colors faded away. Stock head reinforced with a small brass pin. Serial #44XXXX. A delightfully shooting gun with RST light loads. A grouse hunters dream come true.

What grouse hunter would not be intrigued by such a description? To me, it sounded like the absolute perfect grouse gun for hunting out west. Moreover, the price was right. I then had to convince the War Department (my better half) that the acquisition of this gun was a good

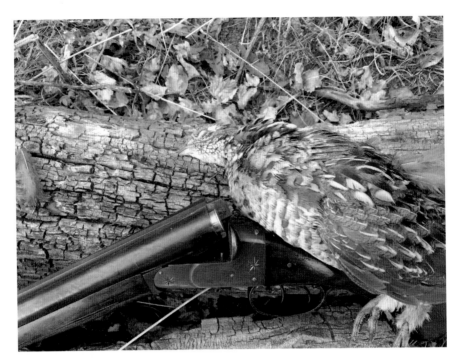

Andy's first ruffed grouse with the Ithaca NID.

investment. With her reluctant approval, I made the commitment to buy the Ithaca NID.

For those who do not know, Ithaca replaced the Flues model with the NID (New Ithaca Double) in 1925 and continued to make them until 1948, when Ithaca shifted its focus to the better-selling pump gun. Of the Ithaca's side by sides, Jack O'Connor wrote in *The Shotgun Book*: "The Ithaca doubles were a lot of gun for the money, but in the higher grades they were neither as elegant nor as expensive as the Parkers, the Foxes, and the L.C. Smiths." However, he also pointed out that "the Ithaca sold for about half what the other companies got for a corresponding grade." So these guns were made for the working-man hunter who couldn't afford the bigger names, which is right up my alley. The seller later informed me on the phone that the gun once belonged to an elderly grouse hunter in Maine who would be glad to know that his gun would once again be carried into the grouse woods—albeit in the Rocky Mountains.

Shortly after purchasing the gun, I learned that many of the great hunting writers also owned and hunted with Ithacas, including Elmer Keith, Gordon Macquarrie, George King (who owned a 1914 Ithaca side by side

The Heartbeat of the Woods

The engraving on the 1927 Ithaca NID.

he couldn't shoot worth a darn because of how light it was) and Michael McIntosh. In fact, McIntosh's NID recently sold for around a whopping $19,000. My forthcoming grouse gun's worth quickly escalated in my mind.

Adding to this, Spencer Jones recently wrote in *Field & Stream's* article "The Fifty Best Shotguns Ever Made"—in which he dubbed the Ithaca NID as the "Underrated Double"—that "Parkers and Foxes get all the love from the gun writers, but the New Ithaca Double was every bit as good. Boasting a lightning-fast (for its day) lock time of 1/625 second, the NID was simple and famously strong."

After reading all this praise for the NID, I can honestly report that I was not disappointed one bit when the gun finally arrived. In fact, it surpassed

my expectations for weight, beauty and elegance. As I snapped the gun up to my cheek with my eyes closed, I was so pleased to be looking down the barrel when I opened them. The gun just fits. The engraving of an English setter on the faded metal receiver was a pleasant surprise and further attested that this is indeed a grouse hunter's gun.

A few days after the gun arrived, I received a case of RST 2½-inch low-pressure shells, compliments of brother Shawn. While trying the gun out that same day, I was tickled by how well it handled and shot where I was looking—although the double triggers will take some getting used to. Things are definitely looking up for this upcoming grouse season.

After I had the chance to shoot the gun, Shawn asked me by text, "Are you stoked about your NID?"

To which I quickly responded, tongue-in-cheek: "Still mad…because now I gotta wait 4½ months to go grouse hunting!"

Chapter 32

THE PERFECT FEELING

Where will man ever come closer to the eternal verities than with the body relaxed and soul at peace in the frosty woods?
—Grampa Grouse

In his rare book *Partridge Shortenin': Being an Instructive and Irreverent Sketch Commentary on the Psychology, Foibles and Footwork of Partridge Hunters*, Grampa Grouse (Gorham L. Cross) describes that magical feeling a bird hunter sometimes gets while in the uplands:

> *Every seasoned bird shooter has known "that perfect feeling." It comes at no particular time or under any especial set of physical conditions.... You will be hunting under just ordinary circumstances when suddenly a feeling of effortless well-being and confidence floods your mind and body.... The man, the gun and the pacing of the cover fall into perfect effortless correlation, all part of some God-like trance or nervous hypnotism which gives a man the feeling that as sure as a bird gets up, the gun will kill him.*

After having hunted birds for almost twenty years, I can attest to this *feeling*. It doesn't happen very often, but when it does, it sure is special. I experienced the *feeling* one glorious day in October 2015 on the last day of the Wayment brothers' annual week of upland game hunting in Idaho. To fully appreciate this story, however, you have to understand the back story.

Idaho Ruffed Grouse Hunting

In March 2015, I purchased what was advertised as "the perfect grouse gun." It was a 1927 Ithaca NID side by side with twenty-eight-inch barrels choked cylinder and cylinder and double triggers. I had such high hopes for the forthcoming hunting season.

To my chagrin, on opening day in September, as I walked a logging road in search of blue grouse, I missed the very first shot at a bird, which gave me my favorite straightaway dropping shot. With the adrenalin pumping, I unsuccessfully tried to tug the front trigger again and never did get to my back trigger.

After this failure, my shooting with the NID only went downhill. I ended up taking a total of three birds with the new gun in September but never with the back trigger. And I burned through so many boxes of precious RST shells to bag those birds. My hopes for the perfect gun were dashed on the jagged rocks of reality.

When Shawn came the last day of September for our annual weeklong hunting trip, I decided to go back to using Ruger Red Labels in 20 and 28 gauge. My shooting improved immediately. To sum up our week, Shawn and I got into birds almost every day, and I shot better than average with the over and unders.

All week long, however, Shawn—a lover of classic side by sides—kept challenging me to shoot the NID. With the sting of the previous monthlong shooting slump still fresh, I was reluctant to switch back. With his incessant encouragement, I finally agreed to try the NID on the last day.

Our destination for the day was our favorite covert, the Royal Macnab, named after the sporting feat described in James Buchan's 1925 novel *John Macnab*. This covert is a large parcel of private property with rolling CRP fields interspersed with three large draws choked with quaking aspens, chokecherry, elder berry and service berry trees. It holds plentiful sharptails, some Huns, a few pheasants and wily ruffed grouse in the timber.

After a successful week, the pressure to succeed had subsided to the point that I really did not care whether or not I shot another bird. I figured this was the perfect time to try the NID.

As I hiked through the CRP, I snapped the light gun up to my cheek to get used to the site picture. I also remembered some shooting advice given by friends. I told my friend Guiseppe Papandrea, "the Grousefather," that I thought I had been shooting high, and he told me, "The NID is a flat shooting gun. Make sure you get your cheek down and you are looking directly over the barrels."

The Heartbeat of the Woods

My good friend Cliff Warmoth—who thought I might be shooting too hastily—advised, "Remember that slow is smooth and smooth is fast." I repeated this phrase a few times as I practiced mounting the gun. I suddenly felt a new confidence I had not felt before.

Within ten minutes of starting our hunt, Shawn's setter, Gretchen, found a sharptail, and Shawn made a nice shot. Shawn and I then made our way up the first CRP field and crossed over the first smaller draw. We continued south over the head of the largest draw on the property onto rolling CRP hills that consistently hold sharptail.

Along the way, I spied Misty on point. As I walked toward her, I then noticed that she was actually honoring Gretchen's point. A covey of Huns flushed hard, and I missed the shot and did not make it to the back trigger in time for a second.

We pushed down the grassy ridges, and a sharptail flushed ahead of us and flew into some trees along the draw's edge at a place we call "the Pinch" because the draw narrows to a point where you can easily cut across it on a game trail. I knew right where that bird lit, and I suddenly had the unmistakable *feeling* that, as soon as the bird flushed, I would surely drop it.

Shawn and I pushed down toward the Pinch, and sure enough, the sharptail flushed out of the thick chokecherries along the tree line, giving me the quartering shot I love so much. I effortlessly raised the gun to my cheek, gave the bird a slight lead, tugged the trigger and it dropped like a stone. Shawn congratulated me on a nice shot. Taking this bird with the NID meant so much more than all the other birds from the previous week's hunting.

Near the Pinch is a round, grass-covered hill. As Misty and I climbed to its crest, I had the strong *feeling* we'd find more birds. As we reached the top, Misty crept forward and stretched out into a beautiful point. When I stepped forward, a sharptail flushed—almost out of range—and I promptly raised the NID and pulled the front trigger, and the grouse fell to the ground. In less than five minutes, I had my limit of sharptails, and it all seemed so effortless.

"Shawn, since I've got my limit of sharptails, I'm going to try and find a ruffed grouse. Why don't you keep hunting the CRP and try and take your limit?" I hollered. Shawn readily agreed.

Misty and I then hunted uphill to the thick tree line above the CRP fields. Once there, we searched the quaking aspen groves but did not find any ruffed grouse. As we treaded along the tree line, I spied a piney hillside across another big draw just off the property. I once had hiked the abandoned logging road traversing the hill and thought it looked like good

Above: A ruffed grouse and sharptailed grouse taken at the Royal Macnab with the Ithaca NID.

Right: Misty admires the fruits of her labors and that perfect feeling.

grouse habitat but did not see any birds at that time. With the magical *feeling* still pulsing through my veins, the piney hill called to me again.

We traversed the deep draw and then hiked up through the quaking aspens and onto the old logging road. Ahead, the sunlight pierced through the Douglas fir–covered hillside into a small opening choked with broomstick aspens and lush ferns—a place that screamed of ruffed grouse. Misty and I walked toward the opening, and she became unmistakably birdy as she picked up scent and worked back and forth to locate its source.

Though Misty did not lock up on point, she was hot on scent when the bird flushed beside her from the thick ferns, giving me an easy quartering shot. The bird dropped, and during my revelry, Misty brought it to hand. I had just gone three for three with the NID, a gun I could not have shot my way out of a paper bag with only a month earlier. And the taking of the ruffed grouse—the king of game birds—was the very pinnacle of my week of hunting in the Idaho uplands. I knew then that there was hope for me and the NID. Now, if only I can figure out how to get to that back trigger!

I am not sure what exactly triggers the *feeling* but suspect it has something to do with the inner peace we often find in the uplands. Like I said, the perfect *feeling* doesn't happen very often, but when it does, it sure is special. Moments of perfection like this keep us coming back for more.

Chapter 33
GROUSE THERAPEUTIC SESSION

The best remedy for those who are afraid, lonely or unhappy is to go outside, somewhere where they can be quite alone with the heavens, nature and God....I firmly believe that nature brings solace in all troubles.
—Anne Frank, The Diary of a Young Girl

Man, work has been stressful! Even if I go grouse hunting, I won't be able to relax and enjoy myself. I hardly ever shoot well when I'm feeling anxious, I argue to try to talk myself out of going hunting.

It's Friday afternoon in November. Winter is coming, and you won't get to hunt grouse very much longer. Besides, a little hunting may do you some good. If you wait until everything is perfect in your life before you go hunting and fishing, you'll never get out, I respond with authority.

"I'm going hunting!" I resolve firmly out loud.

A few inches of snow cover the valley floor as the dogs and I head to our home coverts. I listen to the band Carbon Leaf as the mouth of the canyon comes into view. Although there is not much snow yet, it feels like winter as the afternoon's harsh light reflects off the pale snow. The scenery is a far cry from the halcyon days of October only weeks earlier, but I still love this canyon, its creek and my grouse coverts, even in the bare November days. Just being here brings me comfort, and my work-related stress lessens some.

After a short jaunt up the canyon, I pull the car up next to the gate, which blocks travel into a covert I call the Outhouse. I let Misty and Sunny out, and they are excited as they know and love this place as much as I do.

The Heartbeat of the Woods

I reach for the over and under instead of the side by side, open it and stuff two shells into its chambers. With the recent anxiety, it feels good to have something familiar—something tried and true—in my hands.

I open the gate, and the dogs and I enter a favorite covert into the narrow creek bottom with steep wooded hillsides along its length. The three inches of snow beneath my feet is dry and powdery, which makes for decent walking. The quakies, so full of color earlier, are now barren and have that skeletal look to them. Except for the company of my dogs, the narrow draw feels solemn and lonely.

We pass the sage flat, which has boiled with blues in the past, and the giant service berry grove that straddles the creek bottom. In times past, we always seemed to find a blue or ruffed grouse here, but they are nowhere to be found. The desperate days of grouse hunting are clearly upon us, but it is still good to be out.

With the sharp angle of the sun, its rays are directly on my back, and with the exertion of hiking up the two-track's grade, I actually feel a little warm. The sunlight and the warmth do my psyche good.

We pass the covert's namesake, the outhouse, in the middle of nowhere. Its green door has fallen to the ground in recent years, exposing its insides to the elements. At some time in the past, this was obviously a favorite camping space for someone, but Mother Nature is quickly reclaiming the area, and all of the man-made improvements are slowly fading away. The grouse have taken note, and the dogs and I usually find a ruffed grouse or two in the area. Only a month earlier, brother Shawn and I doubled on a grouse that was only thirty yards from the old outhouse. I reflect on that memory and many more over the years of grouse near the outhouse.

Once past the outhouse, the narrow canyon opens up and forks off in two different directions. The left-hand fork is steeper and leads up to a craggy peak that looks like an ancient, crumbling castle. We've found grouse up there in the past, but I decide to hunt the right fork, which has been good to me over the years.

I follow the cattle trail through the tall sage in the bottom while Misty works the timbered hillside on the right. With her arthritis, old Sunny Girl struggles to just keep going. I feel sorry for her, but her love of hunting drives her on. The path through the sage steepens as it hugs the left side of the canyon. On our right is a big chokecherry thicket bordering the creek bottom. Earlier this season, I missed many grouse in this area.

As I pass the end of the chokecherry grove, Misty is out of sight, but I can hear her bell. She is by the creek bottom. The calmness of the woods

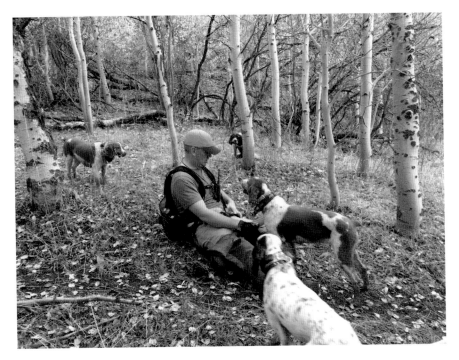

Josh May gets a little therapy with his Brittanys in the grouse woods.

is broken by the thunder of wings coming from Misty's direction. I locate the sound and see the grouse through a break in the trees and mark where it lands.

I know right where that bird went. I believe I can get a shot, I think to myself excitedly.

With the possibility of a shot and a bird, suddenly all of the stress and anxiety from work fade away completely. I feel as if I am getting back to something that really matters.

Sunny and I make our way through the chokecherries to the edge of the steep creek bottom, and sure enough, I see the grouse sitting on a limb. The bird eyeballs me and then flushes hard across the creek, giving me a perfect straightaway shot. The ruff drops at my shot, and Misty quickly brings it most of the way but then drops it down in the snowy creek bottom. Sunny Girl, who has always been a great retriever, gets to the bird and picks it up in her mouth but cannot make it back up the steep hill with her terrible arthritis. So I go to her. This is the only bird she has had in her mouth this whole season, and I am happy for her. I take the bird—an intermediate

phase that is a mix between a brown and gray phase—from Sunny and admire its beauty.

The thought crosses my mind: *This may be the last grouse Sunny ever retrieves. Heaven forbid!*

The dogs and I hike up to the top of the canyon and move no more birds. Oh well, one is plenty. I am glad I came. As we make our way back past the same chokecherry thicket along the steep creek bank, I hear Misty's bell go silent. I follow an old cattle trail through the thicket and spy what I had hoped for—Misty on a rock-solid point looking downhill in the direction of the creek!

I slowly walk toward Misty, duck under the low-lying branches and catch a glimpse of the object of Misty's point. I realize, however, that I am not in a good position to take a shot. So I bow under the branch and backtrack a few steps. The nervous bird has had enough and flushes noisily, quartering left to right. I miss with the first barrel, keep swinging and slap the trigger again just as my view of the bird's flight is covered up by a chokecherry bramble. To my utter amazement, the bird falls and tumbles into the snowy creek bottom.

"All right, Misty!" I holler in excitement as she retrieves the gorgeous gray-phased bird to hand. Judging by the bird's location, I believe this same bird burned my biscuits numerous times this year. I am elated by our success.

Though the season is still open, I decide to leave the remaining birds of the Outhouse alone until next year. Two birds is more than enough, and the dogs and I begin the long trek back to the car.

As I walk down the trail with my Brittanys, I feel true gratitude for them, their efforts, my sacred coverts and my life, even if my job gets stressful at times. To think that I almost let my stress and anxiety keep me from going grouse hunting now seems silly, for hunting and fishing actually help me to keep those things in check. This hunt helps me to realize that many of the things we stress over really don't matter all that much in the long run. It's amazing what chasing a feathery footed bird in unkempt places can do for your mental health. It's good therapy!

Chapter 34

BONA FIDE GROUSE DOGS

William Harnden Foster Was Wrong about Brittanys

Poachers dogs. They'll steal your heart.
—Michael McIntosh, A Feisty Little Pointing Dog: A Celebration of the Brittany

Some have touted William Harnden Foster's book *New England Grouse Shooting* as the Bible of grouse hunting. In his article "Book Learnin'" in the January–February 2014 issue of the *Pointing Dog Journal*, the great Tom Davis asserted that Foster "said just about everything that needed to be said—everything important, anyway—about grouse guns, grouse dogs, grouse cover as it relates to the hunter."

While most of Foster's assessments on grouse and grouse hunting have stood the test of time, he was wrong about one thing: the merits of Brittanys as grouse dogs. On this subject, Foster asserted:

> *Some interest is being displayed at the present time in the Brittany spaniel and strong claims are being made in its behalf as a source of grouse dog candidates. Whatever the virtues of this breed may be, or what future fashion may dictate, the Brittany spaniel has not yet proved anything convincing enough to put on the same basis for consideration with the setter or pointer. Furthermore, the upland gunner who can feast his eyes on a statuesque point demands that his bird dog have a tail. He will tell you in one short breath that there is more of a pointing dog's character, emotions and reactions visible in his tail than in his head and body together.*

The Heartbeat of the Woods

When Foster wrote *New England Grouse Shooting*, Brittanys were still fairly new in the States and the jury was still out on their effectiveness as grouse dogs, but much has changed since then.

In almost twenty years of grouse hunting, I personally have owned German shorthairs and Elhew pointers and have hunted behind numerous setters, and with a few exceptions, they were all decent grouse dogs. While they were assets (as opposed to liabilities) in the field, I wouldn't call any of them grouse specialists.

For more than ten years, however, I have mostly hunted with French and American Brittanys, and I can attest that they are indeed grouse dogs—in fact, the best I have hunted behind. They have bird sense, good noses and stylish points and are natural retrievers. Not to mention they generally tend to be more biddable than some of the other pointing breeds and, therefore, can make better companions at home. My French Brittany, Sunny Girl, was definitely not as athletic as pointers or setters, but no dog ever tried harder or loved grouse hunting more.

In 2010, I obtained an American Brittany, Misty, and, when her first hunting season began, I found in her the best of both worlds—biddableness and athleticism comparable to a pointer or a setter. Since that first season, Misty has proved herself time and again as a first-rate grouse dog.

Let me share an example from this past hunting season to illustrate my point. On the Saturday after Thanksgiving, Misty and I finally were able to steal away to the grouse woods for a few hours. We hunted two creek bottoms in southeastern Idaho that I call Easy Pickins' and Butt Kickins' because the first time I hunted them in 2014, I shot the first bird Misty pointed and then put on a dismal display of ineptitude with the scattergun despite Misty and Sunny's stellar performances.

On this November day, the surrounding mountains were lightly covered with snow, but the skies were azure blue over the idyllic mountainous setting. I figured that—like this hunter—any grouse in the area would appreciate the break in the clouds and the sun's bright light and warmth.

On the way down Easy Pickins', we moved no grouse in the creek bottom lined with willows and quakies. When we made it down to its confluence with the main creek, we followed a fence line cut through the forest over to Butt Kickins', another trickle of a tributary with a thickly choked creek bottom, and began the hike up. Besides the tinkle of Misty's bell and the crunch of the snow under my boots, the woods were quiet.

On the left-hand side of the Butt Kickins' is a pine-covered hill, which does not appear to be prime grouse habitat, except maybe as roosting cover.

As I made my way up the bottom, Misty's bell suddenly went silent about twenty-five yards into the dark timber where I could not see her.

I listened for a few seconds to hear whether any birds flushed but didn't notice anything. Thinking the birds would not be in the dark timber, I called to Misty, "Come!"

Misty reluctantly obeyed my command and came back down to the creek bottom. But once Misty saw me and knew that she had my attention, she turned around and headed right back from where she had come. I like to think that my momma didn't raise no dummy, so I followed her this time.

Misty crept catlike through the dark timber about midway up the hill and locked into a beautiful point. Almost heaven-like, the sun pierced through the trees and spotlighted the ground before Misty. I scanned the hillside above her and spied at the crest of the hill the telltale shape of a grouse with her craning neck watching our approach. Of course, I felt a little sheepish for not coming earlier when I first heard Misty's bell go silent but also grateful that she came down to get me.

I walked alongside Misty, and then she crept forward until she was about eight feet from the nervous grouse and again pointed. As I reached Misty's position, the bird turned its back to us, took a few steps and flushed straight up through the trees but dropped back down when I pulled the front trigger. Misty rushed in and retrieved the bird to me, a beautiful gray-phased hen. For me, this was a late-season gratitude grouse, and so much of the appreciation was for Misty.

After taking a few celebratory pictures, Misty and I continued to hunt up the thick creek bottom. We approached a spot where the narrow quakie-filled creek bottom is surrounded by pines on either side of the creek—a birdy-looking spot if ever there was one. Misty worked out of the shady bottom and up onto a boulder next to a fifteen-foot-high Douglas fir shaped like the perfect Christmas tree. The warm sunlight shined over the pines behind me, illuminating Misty, the pine and the surrounding hillside. On top of the boulder, Misty struck a point toward the tree.

I thought to myself, *Man, that is pretty! I've got to get a picture of this!*

I grabbed my iPhone and slowly walked toward her, and just as I was about to take the picture, two grouse flushed from under the Christmas tree, leaving me without a photo or a shot. Despite the blown opportunity, I was elated by Misty's performance. I can honestly say that her point was as intense and pretty as any I have seen from any pointer or setter. This is just one of numerous similar experiences. I consider Misty to be a grouse specialist.

The Heartbeat of the Woods

Misty's Morning by Jason S. Dowd. *www.uplandlowlife.com*.

I submit that it is time to put this issue to rest once and for all. Foster was just plain wrong in his assessment of the breed. For me and many others, Brittanys have proven their worth time and again on the king of game birds, the ruffed grouse. Tail or no tail, Brittanys are bona fide grouse dogs and deserve to be recognized as such.

Chapter 35

RIP VAN WINKLE WAS A GROUSE HUNTER

A New Take on a Classic Tale

As they ascended, Rip every now and then heard long rolling peals, like distant thunder, that seemed to issue out of a deep ravine, or rather a cleft, between lofty rocks, toward which their rugged path conducted.
—Washington Irving, "Rip Van Winkle"

There are people who hunt grouse and there are grouse hunters. We dyed-in-the-wool grouse hunters are a unique lot. It takes one to know one. Most are kind-hearted lovers of bird dogs and nature, and they experience in their unkempt coverts a peace that cannot be found most other places. Many true grouse hunters have foregone fortune and fame for a handful of feathers and firmly believed that they got the better end of the deal.

The literature of grouse hunting often describes hunters who are cut from this same cloth. Notably, William Harnden Foster gave probably the best description of the archetypal grouse hunter in *New England Grouse Shooting*:

> There is an old New England saying to the effect that if you give a man a shotgun, a bird dog and a violin, he won't amount to a damn. Nothing could better describe an occasional individual who was one to be found in the pa'tridge country. Irresponsible, shiftless if you must, he was the lovable character who planned his future a day at a time, who had the instincts of an Indian and the soul of a poet. Dressed like a tramp he would roam the covers all through the gunning season and look for a job only when it was

over. When he crossed a brook he must step on a hassock or two with the hope of seeing a trout dart out. Then he looked deeper for the big deformed fresh water clam that he would rake out and open eternally hoping to find the pearl of great price. When he came to the spring hole, he looked for signs of mink, for future reference, and he never failed to take a few turns across the exposed sand plain above the bow in the river in order that he might pick up an occasional arrow-head. Then off he would go through the covers behind his dog that was as much like him in temperament and action as an animal could be. Yes, and this erstwhile character of ours would sit behind a stove and play his fiddle and dream of we know not what. But of all the pa'tridge gunning companions he was apt to be the best for he got more out of it than most, and he lived to a ripe old age.

When I first read this description, it had a familiar ring to it, but I couldn't quite put my finger on its source. However, the other day—during another stressful day in the practice of law—while daydreaming of the forthcoming hunting season and my hankering to steal away to the grouse woods, an interesting thought crossed my mind: *I'm Rip Van Winkle!*

It then struck me that the fictional character from my childhood, Rip Van Winkle, fits squarely within the archetype of a grouse hunter, which begs the question: *Was Rip Van Winkle a grouse hunter?* Of course, I had to go back to the classic story to find out.

Most every American has heard or read "Rip Van Winkle" by Washington Irving, the story of a good-natured—but henpecked—man who seeks refuge from his despotic wife in the Catskill Mountains with his fowling piece and his dog, Wolf. As the legend goes, one day Rip is out hunting with Wolf and, after taking a short rest, sees and helps a strange man carry a keg up the mountain, while hearing strange, thunderous noises. When they come to the source of the noise, Rip sees numerous strangely dressed men playing Nine Pins, which sounds like bowling. They all partake freely of the drink from the keg, and Rip sneaks a few flagons himself and falls asleep.

When Rip awakes, he believes that he only slept through the night, but when he arises he finds his dog missing and his gun rusted and worn. When he makes it back to town, he is confused by all the changes around him and learns that he has been asleep for twenty years while the Revolutionary War and the founding of our nation had taken place. This story has a haunting feel and message that's hard to forget, which explains why it is Irving's most famous work. However, I believe the intimate details of Irving's classic story usually escape us.

The Heartbeat of the Woods

Rip Van Winkle Was a Grouse Hunter by Andrew M. Wayment.

Idaho Ruffed Grouse Hunting

I enjoyed rereading the classic and was surprised to see how accurate my hunch was about Rip Van Winkle. In the story, Rip is described as a "simple good-natured fellow" who had a "meekness of spirit which gained him such universal popularity." In my experience, most grouse hunters fit this bill. They are gentle, generous souls who are easy to befriend and to spend time with afield and abroad. Like Rip, grouse hunters oftentimes find that their clothing style is out of fashion—like they were born in the wrong era—but they don't care.

Irving goes on to state that Rip "was one of those happy mortals, of foolish, well-oiled dispositions, who take the world easy, eat white bread or brown, whichever can be got with the least thought or trouble, and would rather starve on a penny than work for a pound." Furthermore, Rip had

> *an insuperable aversion to all kinds of profitable labor. It could not be from want of assiduity or perseverance; for he would sit on wet rock, with a rod as long and heavy as a Tartar's lance, and fish all day without a murmur, even though he should not be encouraged by a single nibble. He would carry a fowling piece on his shoulder for hours together, trudging through the woods and swamps, and up hill and down dale, to shoot a few squirrels or wild pigeons.*

The same could be said of grouse hunters in pursuit of grouse. By no means am I saying that grouse hunters are lazy or irresponsible. Rather, to paraphrase something the great Robert Travers said of trout fishermen, which applies equally well to grouse hunters: "Under his smiling coat of tan there often lurks a layer of melancholy and disillusion, a quiet awareness—and acceptance—of the fugitive quality of man and all his enterprises. If he must chase a will-o'-the wisp he prefers that it be a grouse. And so the grouse hunter hunts."

When life became unbearable for Rip, "his only alternative, to escape from the labor of the farm and the clamor of his wife, was to take gun in hand and stroll away into the woods." Likewise, grouse hunters cherish the time they spend in the grouse woods and oftentimes see it as a great escape from the stress of the workaday world. I believe grouse hunters can closely relate to Rip and his love of wild places.

But the thing that brings Rip squarely within the brotherhood of grouse hunters has to be his tight relationship with his dog, Wolf. Of this, Irving states: "Rip's sole domestic adherent was his dog Wolf, who was as much henpecked as his master; for Dame Van Winkle regarded them as

companions in idleness, and even looked upon Wolf with an evil eye, as the cause of his master's going so often astray." How many grouse hunters have been in the figurative dog house with their spouses because of the time they spend with their bird dogs?

Wolf was not just Rip's companion; he was surely a hunting dog, as the author states, "He was as courageous an animal as ever scoured the woods." The use of the term "scoured" is familiar to any grouse hunter who has watched his dogs tack the thick cover in search of an elusive grouse.

While Rip and Wolf share their lunch together, Rip says to his beloved dog, "Whilst I live thou shalt never want a friend to stand by thee." Any person who has spent time afield with his bird dogs understands the special bond a hunter and his dog share in their common endeavor.

The landscape and the cover in the story also fit the bill for grouse cover. The story takes place in the grouse woods, and there are numerous references to "stone fences," which are a common touchstone (no pun intended) in almost every grouse hunting story from back east. A close reading of the story hints that Rip loved the unkempt places, as the author says his farm "was the most pestilent little piece of ground in the whole country." While poor for crops, such husbandry sounds like a recipe for creating good grouse and woodcock cover as the wilds reclaim Rip's once-cleared land.

The woods themselves, as described in the story, also reek of grouse, as the author describes Rip "working his toilsome way through thickets of birch, sassafras, and witchhazel, and sometimes tripped up or entangled by the wild grapevines that twisted their coils or tendrils from tree to tree, and spread a kind of network in his path." Many a grouse hunter has surely been tripped or horse-collared as he busts through such cover.

So Rip has all the makings of a diehard grouse hunter, but you may still be asking: *Where are the grouse in his story?* And that's a fair question. The story relays that on the fated day in question, "in a long ramble of the kind on a fine autumnal day, Rip had unconsciously scrambled to one of the highest parts of the Catskill mountains. He was after his favorite sport of squirrel shooting, and the still solitudes had echoed and re-echoed with the reports of his gun."

Admittedly, the story plainly states that Rip was "squirrel shooting" rather than pursuing grouse, but that doesn't necessarily mean he was not grouse hunting. First off, you don't need a dog to go squirrel hunting, but Rip always hunted with Wolf. Secondly, while genuine and friendly, most grouse hunters are a secretive lot about their treasured coverts and their sport. Therefore, it's not out of the question that Rip used the guise of squirrel hunting to

hide his real purpose of grouse hunting. The author writes that in telling his own story, Rip "was observed, at first, to vary on some points every time he told it, which was doubtless, owing to his having so recently awaked. It at last settled down precisely to the tale I have related, and not a man, woman, or child in the neighborhood, but knew it by heart." May I suggest that the story varied at first not because Rip had just awakened but because he was trying to protect his secret grouse coverts?

Third, one cannot ignore the thunderous noises that Rip kept hearing in the story as he was helping the strange man carry the keg up the mountain: "As they ascended, Rip every now and then heard long rolling peals, like

Partridge on Parchment by M.R. Thompson. *www.uplandart.com*.

distant thunder, that seemed to issue out of a deep ravine, or rather a cleft, between lofty rocks, toward which their rugged path conducted." While most reading the story would assume that the thunder sounds came from the weather or the haunting Hendrick Hudson and his crew of the Half-moon playing at Nine-Pins, every grouse hunter knows better. That noise comes only from the "wings of thunder" a grouse hunter knows so well. Besides, who bowls in the woods anyway?

Are you still not satisfied? When Rip awakens from his deep sleep, "he looked round for his gun, but in place of the clean well-oiled fowling-piece, he found an old firelock lying by him, the barrel incrusted with rust, the lock falling off, and the stock worm-eaten." To his consternation, Rip also finds his beloved dog missing: "Wolf, too, had disappeared, but he might have strayed away after a squirrel *or partridge* [my emphasis]." There, my friends, is the telltale statement in the story! In New England, the ruffed grouse has been called "partridge" for centuries. Whether Washington Irving knew it or not when he penned this grand tale, Rip and his dog, Wolf, were clearly hunters of the lordly partridge.

This classic tale ends with the following lines: "It is a common wish of all hen-pecked husbands of the neighborhood, when life hangs heavy on their hands, that they might have a quieting draught of Rip Van Winkle's flagon." If by "Rip Van Winkle's flagon" you mean grouse hunting, I'll take a draught anytime.

Chapter 36

DISCOVERING TINKHAMTOWN

The road was long, but he knew where he was going.... He was going back to Tinkhamtown.
—Corey Ford, "The Road to Tinkhamtown"

Undoubtedly, Corey Ford's "The Road to Tinkhamtown" is a classic in outdoor literature. What's not to love when the story touches upon such themes as the relationship between a man and his bird dog; a secret, heavenly covert; and what happens after death? This classic story is a fictional account of a hunter by the name of Frank passing on to that great covert in the sky, which, to his delight, happens to be one of his favorite ruffed grouse coverts, dubbed "Tinkhamtown." This story was first published in *Field & Stream* after Corey Ford passed away in 1969.

What many do not know is that the complete version of "The Road to Tinkhamtown" as originally penned by Corey Ford was not published until 1996 in *Cold Noses and Warm Hearts: Beloved Dog Stories by Great Authors*. Laurie Morrow, the editor of that book, was appointed in 1994 by the Trustees of Dartmouth College, which houses the Corey Ford Archives, as Ford's official biographer. The complete version shows some marked changes from the *Field & Stream* version. For example, in the *Field & Stream* version, Frank's dog is named Shad and the concerned woman talking with Doc Towle is Frank's sister, whereas in the original version, the dog's name is Cider and the woman is Frank's wife.

Despite the variances, both versions of "The Road to Tinkhamtown" describe things and places that Ford knew very well. Although fictional, "The Road to Tinkhamtown" contains many elements of fact. We know that Ford had a setter named Cider. The late William G. Tapply wrote of hunting with Corey Ford and shooting his first grouse on the wing over Cider's point. We learn from Laurie Morrow that Ford truly had a prized, secret covert named Tinkhamtown, and he never did go back after Cider died. Most readers of the story, who know some of Ford's history, agree that the subject of the story is really Corey Ford himself as opposed to the fictional Frank (although Ford never married).

With so many truths therein, the questions arise: What is fiction and what is fact within the story? Who actually discovered Tinkhamtown? How was it found? This essay attempts to answer some of these questions on this timeless classic.

In the story, Ford relates the finding of Tinkhamtown as he makes his way along the road:

> *Everything was the way he remembered. There was a fork in the road, and he halted and felt in the pocket of his hunting coat and took out the map he had drawn twenty years ago. He had copied it from a chart he found in the Town Hall, rolled up in a cardboard cylinder covered with dust. He used to study the old survey charts; sometimes they showed where a farming community had flourished once, and around the abandoned pastures and under the apple trees, grown up to pine, the grouse would be feeding undisturbed. The chart had crackled with age as he unrolled it; the date was 1847. It was the sector between Kearsage and Cardigan Mountains, a wasteland of slash and second-growth timber without habitation today, but evidently it had supported a number of families before the Civil War. A road was marked on the map, dotted with X's for homesteads and the names of the owners were lettered: Nason J. Tinkham, Libbey, Allard, R. Tinkham. Half of the names were Tinkham. In the center of the map—the paper was so yellow he could barely make it out—was the word Tinkhamtown.*

As Frank the ailing hunter's life fades, he tries to communicate with his wife:

> *Why, there was nothing to be worried about. He wanted to tell her where he was going, but when he moved his lips no sound came. "What?" she*

asked, bending her head lower. "I don't hear you." He couldn't make the words any clearer, and she straightened and said to Doc Towle: "It sounded something like Tinkhamtown."

"Tinkhamtown?" Doc shook his head. "Never heard him mention any place by that name."

He smiled to himself. Of course he'd never mentioned it to Doc. There are some things you don't mention even to an old hunting companion like Doc. Things like a secret grouse cover you didn't mention to anyone, not even to as close of friend as Doc was. No he and Cider are the only ones who knew. They had found it together, that long ago afternoon, and it was their secret. "This is our secret cover," he had told Cider that afternoon, as he lay sprawled under the tree with the grouse beside him and the dog's muzzle flattened on his thigh. "Just you and me." He had never told anybody else about Tinkhamtown, and he had never gone back after Cider died.

In these two passages, Ford describes the process of discovering Tinkhamtown and also the assertion that it was a total secret between himself and his dog. Laurie Morrow apparently believes this statement as true, as she wrote in *Cold Noses and Warm Hearts*: "[B]elieve in Tinkhamtown. It's real. It's where Corey said it was all along. And he kept it in his heart till the day he died."

Undoubtedly, Ford generally kept this treasured covert a secret, but did others—such as any of his closest friends—know about it? The answer is unquestionably, yes.

The key to understanding more about the discovery of Tinkhamtown is found in an all-but-forgotten book written back in 1961. Dan Holland, the son of Ray P. Holland, the legendary editor-in-chief of *Field & Stream*, wrote the mass-produced paperback *The Upland Game Hunter's Bible: A Complete Guide to Game Bird Hunting by One of America's Foremost Sportsmen*, which originally sold for a mere $1.95 back in its day. Despite its plebian beginnings, this is an excellent bird-hunting book with some good information about the upland birds we pursue and some great stories to boot. Sadly, this book is often overlooked as one of the classics in sporting literature even though it warrants attention. In *Gun Dogs & Bird Guns*, the late and great Charley Waterman wrote that Holland's book "deserves more attention than it gets."

In *The Upland Game Hunter's Bible*, we learn that Dan Holland was a very close friend and hunting partner of Corey Ford. In fact, Ford is in the book's cover photo, holding a nice gobbler and wearing his signature grin. The book relates stories of Holland and Ford hunting together for bobwhite,

tinamou (*perdiz* in Spanish), valley quail, turkeys and ruffed grouse, some of which are very funny, as one would expect since Ford was involved.

The extent of Holland and Ford's friendship is evidenced by the following passage of Holland's chapter on ruffed grouse:

> *In no other hunting is the choice of a companion as important. He must have bird sense: the ability to smell out a likely corner then cut its outside edge so that anything flushed will go toward his partner, not away from him. He must have drive, the willingness to plow in and break brush for you as you will break it for him. He must know you and your hunting habits so that you work together smoothly, always properly spaced and in line. Good grouse cover is often so thick it is impossible to see your hunting partner much of the time; therefore, you must know for certain each other's pace and inclinations. And, beyond all, a hunting partner must love the ruffed grouse and all that goes with him: the rugged red, gold, and green hills in which he makes his home, the incomparable feeling of relaxation and well-being that comes with the day's end, and, merely, an appreciation of companionship in the field.*
>
> *For these reasons I do practically all of my ruffed-groused hunting with three men: Hank Doremus, Everett Wood (otherwise known as Woodie), and Corey Ford. I first hunted grouse with Hank in the fall of 1932, with Woodie in the fall of 1935, and the three of us have rarely missed a season together since then. Woodie, on a couple of occasions when stationed in Europe, has flown home in October, Hank has dropped his work in New Jersey and driven north, and I have burned up the highways from Montana to New Hampshire for a week's hunt together. It means that much, and the three of us can move through thick cover together like three fingers in a glove.*
>
> *Corey belongs to this same group, but he is a beginner on the team. We have hunted with him slightly less than twenty-five years, but he has high hopes for us.*

In this passage, Holland, with tongue in cheek, refers to Corey Ford—even after almost twenty-five years of hunting together—as the *beginner* on the team. Undoubtedly, Ford fit the bill for the ideal grouse-hunting companion. He was the fourth finger of the glove, or group, of dedicated grouse-hunting friends.

Of huge significance to the underlying truth about the discovery of Tinkhamtown, Holland wrote as the introduction to the chapter on ruffed grouse:

Idaho Ruffed Grouse Hunting

"Where'd you get the fine pa'tridges?" a farmer asked me as I dragged my feet wearily down the little New Hampshire road to my parked car.

"Tinkhamtown," I answered.

"Ain't no sech place," he snapped back. "Lived in these parts all my life—well, not quite yet, but so far—and there ain't no sech place."

I told him that Tinkhamtown was across the mountain within walking distance of where we stood. I knew because I had been there, taken my limit of grouse and had come back all in the same day. The mystery was explained by an old map I had chanced on which clearly showed a town and farming community which no longer existed. Being a partridge hunter, I had hiked there, found the old cellar holes, the vanishing traces of pasture land, the overgrown orchards and ruffed grouse almost in flocks. I explained this to my friend. He cogitated for a moment and allowed as how it might be a fact: long ago there were farms over the mountain, but no more. The last resident had moved out at least sixty years ago.

"Over to Concord, that's where they went, I warrant," he remarked a little scornfully. "Some of them went clean to Boston, maybe." "Yep," he added proudly, "it takes a right good man to farm this country."

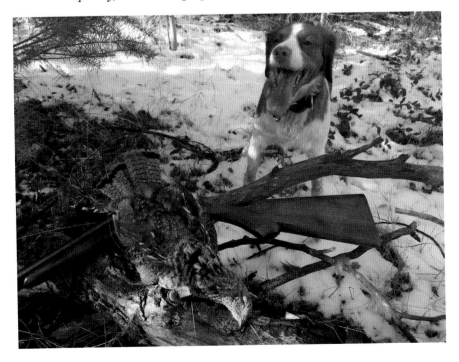

Misty's last grouse.

The Heartbeat of the Woods

As you can see, Corey Ford was *not* the only one who knew about Tinkhamtown or the first to write about it, for that matter. In fact, according to Holland, he—rather than Corey Ford—is the one who discovered the map that led to this special covert. In reality (as opposed to the fictional story), Holland most likely passed this top-secret information on to Corey Ford and they hunted there together. And Corey Ford later wrote one of the greatest hunting stories ever about this special place.

Notably, in the last part of Ford's "The Road to Tinkhamtown" (as he originally penned it), as Frank passes on to Tinkhamtown: "He paused at the stream just for a moment. He heard men's voices. They were his hunting partners, Jim, Mac, Dan, and Woodie." Unfortunately, this passage was not included in the *Field & Stream* version. Now we know that the "Dan" of whom he speaks is none other than his good friend and hunting companion Dan Holland, the author of *The Upland Game Hunter's Bible*. Of course, Ford couldn't leave out the very friend who showed him this extraordinary covert in the first place. When the editor of *Field & Stream* cut out this sentence, he cut out a very significant theme of the story: one of friendship.

Regardless of who discovered Tinkhamtown, the story remains one of the greatest sporting stories ever written. The timeless themes strike a chord with every bird hunter who ever spent a day afield in a cherished covert with a beloved bird dog—a little piece of heaven, if you will. At least that is how Corey defined heaven: "No...it isn't someplace else. It's somewhere you've been where you want to be again, some place where you were happiest."

GLOSSARY

For those of you who are new to this sport, I thought a glossary defining the vernacular of grouse hunters may be helpful.

BANNER DAY: A day when the birds are plentiful, the dog work is stellar and the ol' shooting eye comes through for a change. Grouse hunters live for such days.

BIRDBRAIN: A term similar to Brush Worn (below). Basically, it's a person who would rather hold a handful of feathers than a handful of gold any day.

BIRDY: When a place just screams that there are birds around, the cover is "birdy" looking. This term is also used to describe a dog that is actively working the scent of a bird.

BLUES: No, this is not a form of music in grouse hunting but, rather, the ruffed grouse's bigger cousins, dusky grouse, that are sometimes found close to ruffies. They used to be named "blue grouse," but the official name was recently changed by the uppity-ups to "dusky grouse." To me, they will always be just blues. Regardless of what you call them, blues are grand game birds in and of themselves.

BRUSH WORN: This term was coined by the late and great George King to describe members of the Ancient Order of Honorable Brush Worn

Glossary

Patridge Hunters. More generally, Brush Worns are those individuals who absolutely love and live for ruffed grouse hunting.

BURN MY BISCUITS: When a grouse jukes and jives so well that you blow one or two holes in the sky or into a tree to no effect, that bird just burned your biscuits.

COVER: The actual vegetation the birds use for food and protection.

COVERT: Those secret, almost sacred places where grouse hunters have reliably found birds in the past.

DARK TIMBER: This is a term used to define the old-growth pines that are often found close to quakies. Dark timber is not the best habitat for ruffed grouse, but they do use it to roost and for protection from the elements.

DEADEYE: The manifestation of the Schizophrenic Wingshooter (defined below) who is a good shot.

DUDLEY: The manifestation of the Schizophrenic Wingshooter who couldn't hit the back side of an elephant with a scattergun.

DUSKIES: Another nickname for dusky grouse but less used than "blues."

EDISON MEDICINE: When you have a knucklehead bird dog that will not listen to your commands, a little Edison medicine from an E-collar is just what the doctor ordered. *See also* electrical persuasion.

ELECTRICAL PERSUASION: Electrical persuasion is the use of an E-collar to bend a crazy bird dog's will to your own. Also known as "Edison medicine."

GLORY DAY: A glory day is also a banner day in the grouse woods but takes place during the very height of creation, the month of October. You only get so many glory days, so get out and savor them.

GROANER: Those easy chip shots at birds that you have no excuse for missing and that haunt your dreams in the off-seasons.

Glossary

GROUSE WOODS: The special places you find ruffed grouse and a little peace of mind. Without grouse, they are just a boring old forest.

GROUSEY: This term is similar to birdy but more specific to ruffed grouse. Such grousey places just have to hold Ol' Ruff.

GROUSING: This term can either mean the pursuit of ruffed grouse or the grumbling that occurs when you miss one.

GRUDGE: No, I didn't invent this word. It came from Grampa Grouse (Gorham L. Cross, the author of the singular book *Partridge Shortenin'*). But I sure as heck use this word to describe those times when I place a curse on a ruffed grouse that repeatedly burns my biscuits. I've grudged quite a few birds in my day.

JACK-SLAPPED: When a bird burns your biscuits so bad he may just as well have slapped you silly, you just got jack-slapped.

JO JO THE IDIOT CIRCUS BOY: This is your nickname when you hear the sudden thunder of a ruffed grouse and you get grouse fever so bad you couldn't shoot your way out of a paper bag.

NEMESIS: The game bird species that is currently and consistently kicking your butt. In my younger days, ruffed grouse were on the list of nemeses, but my current list includes chukar and pheasant.

OL' RUFF: A nickname for an old ruffed grouse that has proven to be a wily and worthy adversary. Such birds may need to be grudged.

PICKINS': I also did not make up this term, as it has been used by many others, including Grampa Grouse. Basically, it means the birds (or lack thereof) found in a covert. If things are good, you may find easy pickins'. If things are slow or your shooting doesn't measure up, things may be slim pickins'. Slim pickins' often goes hand in hand with a thorough butt kicking.

QUAKIES: A nickname for quaking aspens, a member of the poplar family, which is usually the preferred habitat for ruffed grouse in the West.

Glossary

RED LETTER DAY: A day of hunting that starts off a little shaky but turns into a banner day.

ROADSIDE REVELATION: This is a term I coined to define those times when you find a new covert by spying a bird right beside the road and then hunting the surrounding area. Bill Tapply called such birds "road birds." George King called them "Judas birds." Either way, this phenomenon is a heavenly manifestation, which is why it's called a "roadside revelation."

RUFFIE: A term of endearment for the ruffed grouse.

SCHIZOPHRENIC WINGSHOOTER: This term describes me as a wingshooter. Some days I shoot fairly well, and sometimes I couldn't shoot my way out of a paper bag. The problem is, I never know who is going to show up: Deadeye or Dudley. I am the Schizophrenic Wingshooter.

SEED BIRD: Most ruffed grouse hunters are careful not to shoot out their coverts. Thus, a bird left to propagate the species is called a "seed bird." Oftentimes, this term is used tongue in cheek to describe those birds that burn your biscuits.

SHARPIES: Yes, this is the name of a marker, but it also happens to be the nickname for the sharp-tailed grouse, an awesome game bird in his own right.

TWEETY BIRD: A term used to describe a bird that is *not* a ruffed grouse. Others have called them "stink birds."

BIBLIOGRAPHY

Babcock, Havilah. *The Best of Babcock.* New York: Holt, Rinehart and Winston, 1974.

Claflin, Wm. H., Jr. *Partridge Rambles and Partridge Adventures.* Prescott, AZ: Wolfe Publishing Co., 2014.

Davis, Tom. "Book Learnin.'" *Pointing Dog Journal* (January–February 2014).

———. "Were the Good Old Days That Good?" *Ruffed Grouse Society Magazine 50th Anniversary Issue* 13 (2011).

Ford, Corey. *The Trickiest Thing in Feathers.* Gallatin Gateway, MT: Wilderness Adventures Press, 1996.

Foster, William H. *New England Grouse Shooting.* Oshkosh, WI: Willow Creek Press, 1942.

Grouse, G. *Partridge Shortenin': Being an Instructive and Irreverent Sketch Commentary on the Psychology, Foibles and Footwork of Partridge Hunters.* N.p.: Gorham L. Cross, 1949.

Haig-Brown, Roderick L. *A River Never Sleeps.* New York: Nick Lyons Books, 1974.

Hill, Gene. *Shotgunner's Notebook: The Advice and Reflections of a Wingshooter.* New Albany, OH: Countrysport Press, 1989.

Holland, Dan. *The Upland Game Hunter's Bible.* Garden City, NY: Doubleday & Co., 1961.

Holland, Ray P. *Scattergunning.* New York: Alfred A. Knopf, 1951.

Jones, Spencer. "Ithaca NID" in "The 50 Best Shotguns Ever Made." *Field & Stream.* Accessed November 6, 2007. www.fieldandstream.com/photos/

gallery/guns/shotguns/shotgun-reviews/2007/11/50-best-shotguns-ever-made?photo=18.

King, George. *That's Ruff!: Reflections from Grouse Country.* Claridge, PA: Concord House Publishing, 2010.

Lundrigan, Ted Nelson. *A Bird in the Hand.* Camden, ME: Countrysport Press, 2006.

———. *Hunting the Sun: A Passion for Grouse.* Traverse City, MI: Countrysport Press, 1997.

Maclean, Norman. *A River Runs Through It and Other Stories.* Chicago: University of Chicago Press, 1976.

Mathewson, Worth. *Best Birds: Upland & Shore.* Mechanicsburg, PA: Stackpole Books, 2000.

Morrow, Laurie, ed. *Cold Noses and Warm Hearts: Beloved Dog Stories by Great Authors.* Minocqua, WI: Willow Creek Press, 1996.

O'Connor, Jack. *The Shotgun Book.* New York: Alfred A. Knopf, 1965.

Parman, Mark. *A Grouse Hunter's Almanac: The Other Kind of Hunting.* Madison: University of Wisconsin Press, 2010.

Pero, Thomas R., ed. *A Passion for Grouse: The Lore and Legend of America's Premier Game Bird.* Millcreek, WA: Wild River Press, 2013.

Spiller, Burton L. *Drummer in the Woods.* Fairfax, VT: Upland Publishing, 2012.

———. *Fishin' Around.* New York: Winchester Press, 1974.

———. *Grouse Feathers.* New York: Crown Publishers Inc., 1972.

———. *More Grouse Feathers.* New York: Crown Publishers Inc., 1972.

Tapply, William G. *Those Hours Spent Outdoors: Reflections on Hunting and Fishing.* New York: Charles Scribner's Sons, MacMillan Publishing Co., 1988.

———. *Upland Autumn: Birds, Dogs, and Shotgun Shells.* New York: Skyhorse Publishing, 2009.

———. *Upland Days: 50 Years of Bird Hunting in New England.* New York: Lyon's Press, 2000.

Thomas, E. Donnall. *Fool Hen Blues: Retrievers & Shotguns, and the Birds of the American West.* Bozeman, MT: Wilderness Adventures Press, 1994.

Tolkien, J.R.R. *The Lord of the Rings.* 2nd ed. Ithaca, NY: Houghton Mifflin Co., 1993.

Traver, Robert. *Trout Madness.* New York: St. Martin's Press, 1960.

Trueblood, Ted. *The Ted Trueblood Hunting Treasury.* New York: David McKay Company, Inc., 1978.

Waterman, Charles F. *Gun Dogs & Bird Guns: A Charley Waterman Reader.* South Hamilton, MA: GSJ Press, 1986.

———. *Hunting Upland Birds.* New York: Winchester Press, 1972.

Wayment, Andrew. *Heaven on Earth: Stories of Fly Fishing, Fun & Faith.* Salt Lake City, UT: American Book Publishing, 2012.

Webb, David A., ed. *A Feisty Little Pointing Dog: A Celebration of the Brittany.* Camden, ME: Countrysport Press, 2000.

Woolner, Frank. *Grouse and Grouse Hunting.* New York: Crown Publishers, Inc., 1970.

ABOUT THE AUTHOR

Andrew M. Wayment ("Andy") is an attorney by profession and an outdoorsman by passion. Andy is a partner with the law firm Tolson & Wayment, PLLC, in Ammon, Idaho, where he helps clients in and out of court. Andy's family includes his beautiful wife, Kristin, four daughters, two sons and one bird dog: Topperlyn Rainey Creek Ruff. In his free time, Andy enjoys writing and has published numerous articles on upland bird hunting and fly-fishing in various magazines and the local newspaper. His first book, *Heaven on Earth: Stories of Fly Fishing, Fun & Faith*, was published in 2011 and received numerous positive reviews. Andy also writes for two blogs, Upland Ways and Tenkara Wanderings. When Andy is not at work or with his family, you may find him at the river waving a fly rod or in the grouse woods toting a shotgun and following his bird dog.